AFRICAN ARTS
& CULTURES

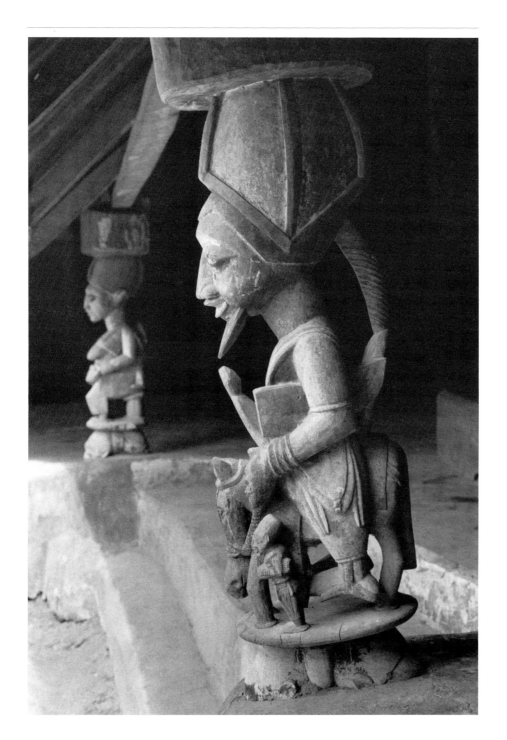

Veranda Posts
Agbunbiofe Adeshina, Yoruba people of Nigeria, 1916. Wood. Courtesy of the National Museum of African Art. Photograph by Eliot Elisofon, 1970.

AFRICAN ARTS & CULTURES

Jacqueline Chanda

Davis Publications, Inc.
Worcester, Massachusetts

Acknowledgements

While the task of improving perceptions and attitudes toward descendants of Africa is an educational challenge within the classroom and beyond, the African presence continues to influence and inspire the musical, visual and dramatic arts around the world. I hope this book will contribute to the process of cultural enlightenment.

I would like to thank Dr. Roy Sieber, associate director of the National Museum of African Art (Smithsonian Institution) and professor at Indiana University (Bloomington); Dr. Veronika Jenke, assistant curator of education at the National Museum of African Art; and Dr. Vesta Daniel, associate professor of art education at The Ohio State University for their encouragement and constructive comments throughout the development and writing of this book. I am grateful for the help and information I received from Dr. Chris Geary, curator of photographic archives at the National Museum of African Art; Fred Smith, director of the Kent State University School of Arts gallery; Dr. Robert Soppelsa, professor at Washburn University; and Marie Louis Bastin, professor at the Université Libre de Bruxelle. I would also like to thank the National Museum of African Art, The Metropolitan Museum of Art, and the many other museums, galleries and collectors who provided images. Finally, I must thank Wyatt Wade and the dedicated staff at Davis Publications for their support and understanding.

Cover:
Three Women Outdoors (detail)
Photograph © Margaret Courtney-Clarke.

Editor: Nancy Burnett
Design & Composition: Greta D. Sibley

Library of Congress Catalog Card Number: 92-7390
ISBN: 87192-249-5
10 9 8 7 6 5 4 3 2

CONTENTS

PREFACE

This book is an introduction to the art and culture of Africa south of the Sahara. One of my intentions here is to dispel the notion that sub-Saharan Africa consists of one homogenous culture. Rather, Africa is a complex continent rich with many different peoples representing a wide variety of cultures. The works of art created in Africa convey political, social and economic themes and are visual proof of the diverse nature of these peoples.

I have tried to present an accurate image of this cultural diversity. However, it was not possible within the limits of this book to represent all cultures. Therefore, I have made an effort to include information about some of the familiar cultures, such as the Yoruba and the Asante, and less familiar, such as the Chockwe and Lunda. Part of the text was developed from research I had completed during a six year stay in south central Africa where I worked and studied. Other parts come from the contributions of specialists in the field of African art and culture.

INTRODUCTION
Understanding African Art

African art takes many forms, and is made from many different materials. Any work of African art, old or modern, is shaped by the African culture from which it comes.

Luba Pot
This clay pot is believed to be an effigy pot for divination, and is used to identify and cure diseases. *Kanyok people, Shaba region, Zaire. Ethnography. 11 x 7" (27 x 18 cm). Royal Museum of Central Africa, 1980. Tervuren, Belgium.*

Bwa Butterfly or Hawk Mask
Infrequently, sculptures were semiabstract. Notice how the triangular-shaped face, with a hooked horn protruding from the forehead, is flanked by two wing-like projections. The mask represents a protective spirit in animal form.
The hooked nose is said to be symbolic of certain birds such as owls and hornbills, or perhaps the hawk. *Burkino Faso, 19th–20th century. Wood, paint, hemp, 50 ¼" (128 cm). Courtesy of The Metropolitan Museum of Art, the Michael C. Rockefeller Memorial Collection, Bequest of Nelson A. Rockefeller, 1979.*

The power and beauty of African artworks can touch even casual viewers, but true appreciation can come only through understanding the cultural and environmental factors that have influenced its creation. This task would be simplified if it were possible to study African art using Western methods. Books on Western art usually focus on the history of changes in style and the ways artists influenced one another.

African art cannot be studied this way because there is no chronological record of style changes. The climate made the preservation of wood and clay objects difficult. European collectors were rarely interested in the artists and consequently did not record biographical information. Many of the records that do exist are inaccurate and incomplete. Objects cannot be identified by geographic region because several styles are shared by more than one ethnic group.

A more useful way to look at African art is by common themes. These themes, or topics, relate the artworks to their cultural setting, making it possible to understand the value, purpose and significance of a particular work. In addition, when

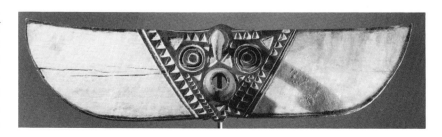

you compare the ways various cultures express a common theme, the similarities and differences among them become fairly obvious.

Scan the Table of Contents for a quick summary of the material covered in this book. The theme "Art for Life," for example, refers to art that focuses on generating life and the beginning of life. Likewise, the "Rites of Passage" theme covers the transition from one stage of life to another; "Art and the Economy" discusses objects used primarily as trade goods. The last chapter, which focuses on art in Africa today, explores changes in form and media, ongoing traditional concepts and innovations of new forms to meet the demands of a changing world.

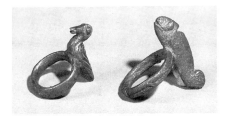

Senufo Bronze Rings
Senufo men wear bronze rings decorated with chameleon or billhorn figures as protective amulets. The chameleon and the billhorn represent two of the five primordial animals that organized the universe. The chameleon is feared because of its mysteriousness, and is believed to have cheated humankind of immortality because of its slowness in delivering a message from God. The billhorn was responsible for carrying the dead into the great beyond. *Senufo people, Côte d'Ivoire. Metal. Collection of Richard Hunt. Photograph courtesy of Vesta Daniel.*

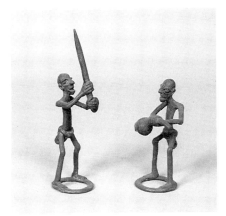

Figurative Gold Weights
The counter weights used for weighing gold dust may look like animals, people or natural objects, such as peanuts, or man-made objects, such as game boards or stools. *Collection of Richard Hunt. Photograph courtesy of Vesta Daniel.*

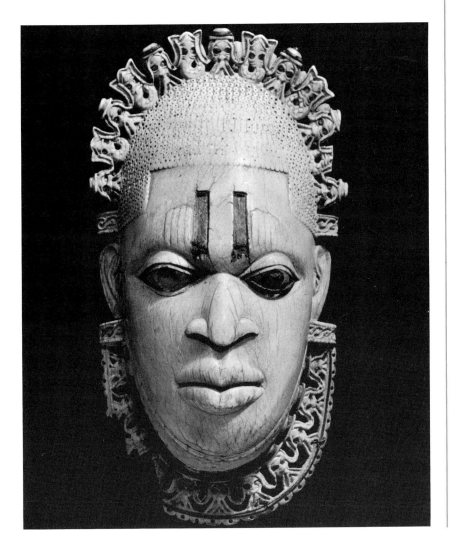

Ivory Miniature Belt Mask
These small masks were typically memorial or funerary symbols. They were placed on an altar or a tomb or carried on a belt. This one was removed from the sleeping chamber of a king, who wore it on his belt on important occasions. A fringe of miniature heads of Portuguese soldiers adorns the crown of this piece. *Benin, Nigeria. Ivory, iron, copper, stone, 9⅜" (24 cm). Courtesy of The Metropolitan Museum of Art, the Michael C. Rockefeller Memorial Collection, Gift of Nelson A. Rockefeller, 1972.*

Environment & People

African cultures can be very different from one another. One belief that all African cultures share, however, is the belief in one creator. Much African artwork shows how Africans feel about their creator and religion.

The second largest continent, Africa today includes over fifty independent countries. It is made up of a series of plateaus that produce low lands in some places and high lands with deep depressions in others. Nearest to the equator—along the coast of West Africa and across central Africa — are the dense tropical rain forests, where heavy rainfall keeps trees green all year. North and south of the rain forests are savannas. These large grassy areas are scattered with trees that lose their leaves in the dry season. North and south of the savannas are the deserts: the Sahara in the north, and the Kalahari in the southwest.

Traditionally, some African societies were pastoral, some agricultural, while still others were hunters and gatherers. To a great extent, the customs of the various peoples were a product of the environment. Pastoral societies, for example, needed large expanses of grazing area for their animals, and so were required to live in the open savannas.

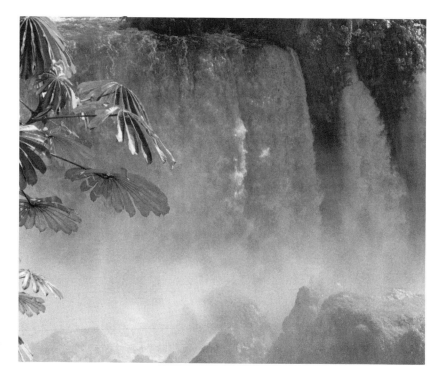

Waterfall near Gungu, Zaire, Pende area
The high plateaus where rivers are located create waterfalls which produce deep depressions in some parts of Africa. *Courtesy of Maya Bracher, National Museum of African Art, 1970.*

Despite their diversity, most African societies shared some central beliefs. Most, for example, believed that the universe was designed by one creator or couple, although the details of creation vary from culture to culture. Most also believed in the existence of the visible and the invisible worlds, the natural and the divine, and this world and the heavens populated by spirits who served as messengers of the creator. These societies also believed that it is necessary for men and women to maintain good relations with the spirits to ensure a pleasant life.

In order to do this, Africans traditionally organized themselves into groups responsible for maintaining these relations and regulating their own behavior. These groups, which were based on kinship, included family, clan, age grades or secret societies. While family and clan membership was automatic, individuals had to be initiated into age grade or secret society groups.

There were two types of family in African society: the extended family and the polynuclear family. The extended family included grandparents, brothers, sisters, nieces and nephews. The polynuclear family was the product of marriage to more than one spouse. When a man married several wives he formed several elementary families. His wives and children did not usually share a single dwelling. Clans could be based on either the female or male line. Clan groups shared or claimed the same ancestors, and were the most important groups for determining daily relationships and social structures. Families and clans were generally nonreligious groups.

Age grades and secret societies were nonkin groups. They were usually religious groups, but some had both religious and nonreligious responsibilities. These men's associations determined one's position, rights and duties. They existed most often in cultures that had no political hierarchy. These groups had economic, military, political and religious functions, and were often responsible for ensuring good relations with the spirit realm through masquerades and rituals.

All religious and nonreligious groups worked together for the good of the community, which was based on the strength of the spiritual relations. Many of these groups are still active today while others have disappeared because of Western influences on religious thought.

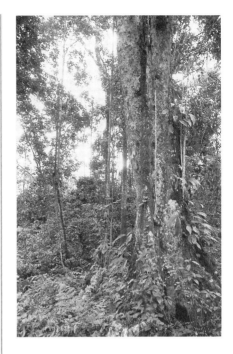

Rain forest near Beni, Zaire
Tropical rain forests center around the equator. The trees are so tall and the foliage so dense that in many areas you can't see the sky. *Courtesy of the National Museum of African Art. Photograph by Eliot Elisofon, 1970.*

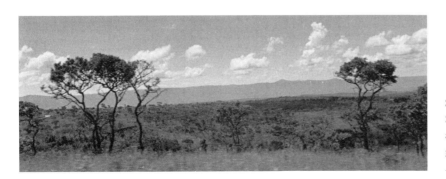

Savanna in Tanzania
Savanna areas are wide open with few trees and an abundance of tall grass, called elephant grass. *Courtesy of the National Museum of African Art. Photograph by Eliot Elisofon, 1947.*

The continuation of social norms was not only reflected in the structures of the community, but also through religious rituals, ceremonies, and nonreligious celebrations. In these domains art played and continues to play an important role. For instance, in some cultures masks were used to regulate laws, while in others, the king had that power. Statues may have been used to calm troubling ancestor spirits in one culture, while in another the ancestor cult is absent altogether.

The appearance of art forms, whether realistic or abstract, was greatly affected by the different cultural values. For instance the Benin peoples of Nigeria adopted a realistic style of portraying people and clothing in their castings, perhaps to clearly illustrate the distinctly stratified social structure. The Dogon of Mali produced very abstract images with little or no detail, perhaps because the idea was more important than resemblance.

The chosen medium for a work of art depended largely on the physical environment or climatic region. If there was not an abundance of stone a carver had to use wood or other material. If trees were small and scarce, but fiber was abundant a maskmaker would use fiber. Regardless of medium, sculptural forms represented the social, political and religious values and customs of the African people. For instance, the calves of the spirit spouse figures carved by the Baule people of the Côte d'Ivoire represent the group's hard work ethic. Similarly, the political and authoritative positions of the Zairian Kuba king is expressed in the posture and attributes of the Ndop figures.

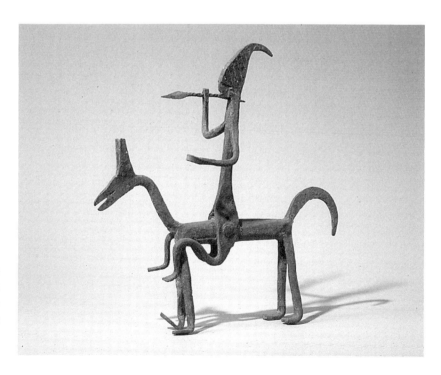

Dogon Equestrian Iron Sculpture
Notice the simplified abstract forms of this family altarpiece. The curvilinear forms of the horse and rider contrast with the linear verticals and horizontals. *Collection of Richard Hunt. Photograph courtesy of Vesta Daniel.*

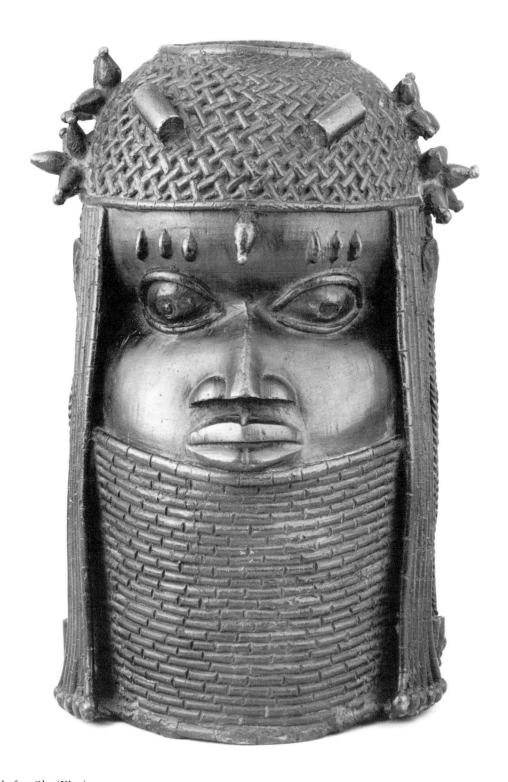

Memorial Head of an Oba (King)
Sculptures from the Benin Kingdom of the fourteenth and fifteenth centuries represent one of the more realistic sculptural traditions in Africa. *Edo people, Nigeria, 18th century. Cast copper alloy, metal inlay. Courtesy of the National Museum of African Art, Gift of Joseph H. Hirshhorn. Photograph by Jeffrey Ploskonka, 1979.*

Introduction

For many years, slave traders and European invaders controlled Africa. Yet African culture lived on. Most African countries are now free.

History

Early Africans passed information about the origins of peoples, historical events, migrations and relationships among communities from one generation to the next through myths, ceremonies and symbols. Despite this rich oral tradition, Westerners have often identified African history as beginning in the fifteenth century, with the arrival of the first European explorers on African shores. Within the last five decades, however, historians and archaeologists have reconstructed some of the early history of Africa by studying both the stories and written documents provided by early Arab and African writers.

The written documentation focuses on the large city-states and empires made up of groups of states or territories under sovereign powers. Many of these city-states and empires were at the height of their prosperity at the time the Europeans entered Africa. The growth of the iron, gold, salt and ivory trades stimulated the growth of trade centers, cities and states in Africa south of the Sahara. For instance, in the tenth century the trade system of Ghana was based on the exchange of gold for salt. The kings traveled north to gain control of imports and south

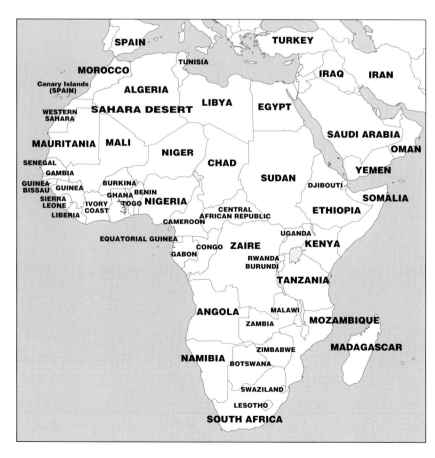

Political Map
This map of Africa shows the countries as they are represented today.

to gain control of buying gold. In addition, exports of iron ore from Africa to India were recorded long before any European contact.

Motivated by a desire for these goods, as well as for slaves, the Portuguese entered Africa in the fifteenth century. The French, Dutch and British followed in the seventeenth century. Soon, the profitable trading partnership shared by Africans and Europeans was soured by the increase in slave trade. Because it depopulated many African kingdoms, the slave trade devastated Africa by opening the door to European control and expansion.

The slave trade continued to weaken Africa for many years. Although it ended during the nineteenth century, hard on its heels came colonization by the European powers. France, England, Germany, the Netherlands, Portugal and Italy all invaded Africa in order to take additional riches. To prevent fighting among themselves, in 1885 the Europeans sliced up Africa into pieces and colonial rule began. By the middle of the nineteenth century, all economic and military power was in the hands of the Europeans.

It would be seventy-two years before Africa would begin to gain its independence. In 1957, Ghana became the first country to obtain freedom. Ghana was followed by others, until eventually most African countries became free. The notable exception is South Africa, in which black Africans are ruled by white South-Africans even today.

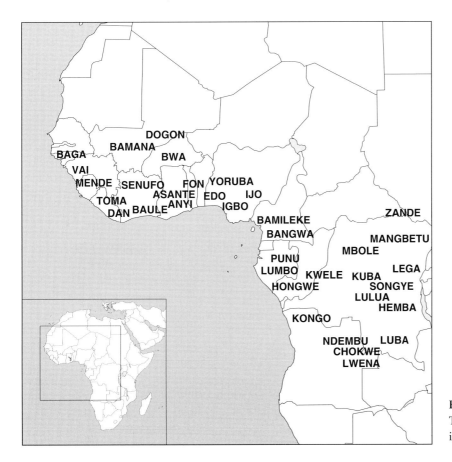

Ethnic Groups of Africa
This map shows the various ethnic groups in Africa south of the Sahara.

Sculpture is the best known African art form. Wood, iron, clay, bronze, ivory and textiles were used to make masks and other sculptures. Some sculptures were thought to contain special powers.

A Sculpture Primer

African sculptors were honored and feared for their mystical powers. In some communities, they lived in an area especially reserved for them on the outer edges of the village. Historically, most sculptors were men (women wove baskets, formed pots and painted walls). Most sculptors began to learn their trade at the young age of twelve or thirteen, when they were apprenticed to experienced artists. At the end of their training the apprentices became eligible to work as part- or full-time sculptors. Part-time sculptors usually held another job, such as blacksmith, farmer or chief. Full-time sculptors most often worked for the royal court on commission.

Because traditional sculptors were bound to follow certain practices, their works share certain similar characteristics. For example, many, although certainly not all, figures have arms that are held to the side, eyes that face forward, and weight that is evenly distributed over both feet. Many sculptures are heavily ornamented. In addition, the shapes and forms of African sculpture often contrast with one another: organic forms may be mixed with geometric forms, and round three-dimensional forms may contrast with flat, relief-carved areas. In many sculptures the rhythmic repetition of swelling, bulging body parts moves the viewer's eye from head to foot.

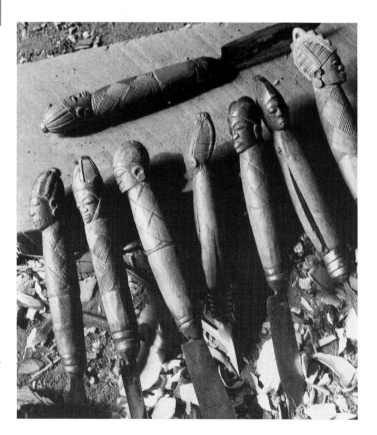

Decorated Sculptor's Tools
Traditional wooden and ivory sculptures were carved with knives from one or more pieces of material. *Yoruba people, Odo-Owa region, Nigeria. Courtesy of the National Museum of African Art. Photograph by Eliot Elisofon, 1970.*

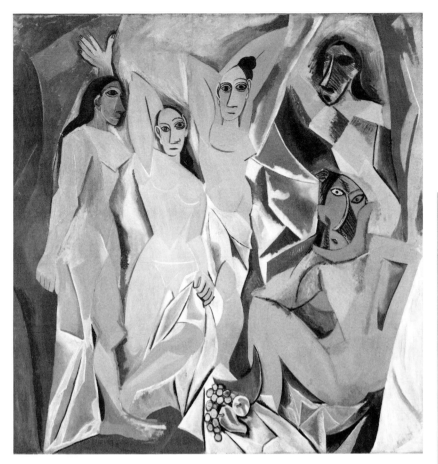

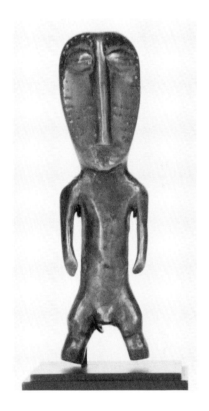

Les Demoiselles d'Avignon, by Pablo Picasso, 1907

Picasso admired African art for its new and formal ideas, and probably for its contrasting use of forms and shapes. Notice how the face of the lower right figure has eyes placed in the upper part of the head like the Lega piece. *Oil on canvas, 8′ x 7′8″ (244 x 234 cm). The Museum of Modern Art, New York. Acquired through the Lillie P. Bliss Bequest.*

Ivory Sculpture
The structure of this figure's head is dominated by a concave face with protruding eyes and nose. The sculpture's ivory color has turned red from handling. *Lega people, Zaire. 6⅛″ (16 cm). Courtesy of Charles Mack.*

Dogon Carver, Ogol du Haut, Mali
In addition to using knives, traditional carvers used adzes (cutting tools with a thin, arched blade) to shape wood and ivory. This blacksmith/carver is working on a Kanaga mask in a cave outside his village. *Courtesy of the National Museum of African Art. Photograph by Eliot Elisofon, 1970.*

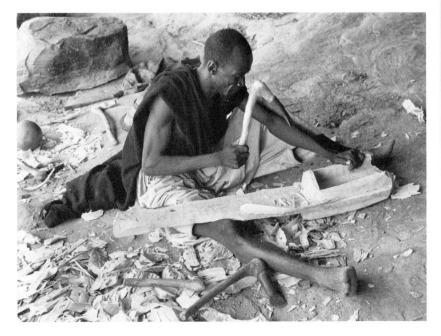

Contrary to popular belief, African sculptures are not systematically symmetrical. In fact, many show asymmetrical compositions. But even in a primarily symmetrical piece, there are always slight irregularities. Other characteristics of African sculptures are enlarged heads, large hands and feet, and protruding navels. African artists often emphasize

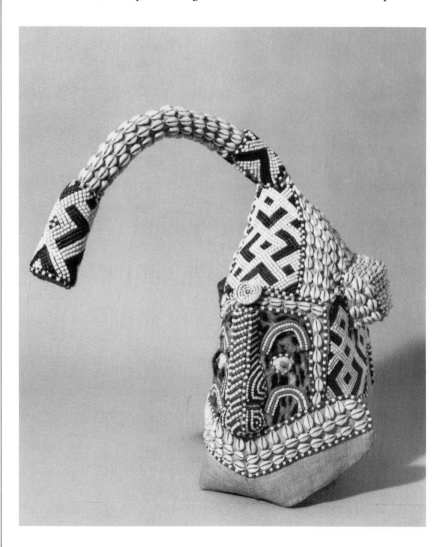

Mwaash A Mboy Mask
The surfaces of African sculptures are usually adorned with metal, cowrie shells, fiber, horns or beads, or black, white and red paint. The ornamentation and arching appendage are signs of kingly power and prestige. The motifs on this 19th-century mask were drawn from textile designs of the Kuba society. *Kuba people, Zaire. Wood, beads, fiber, cowrie shells. Courtesy of the Penn State Museum of Anthropology. Photograph by Richard E. Ackley.*

the head because it is thought to be the center of character and emotion—often, the face is ageless and idealized. The enlarged navel is a symbol of the continuation of life, and the large hands and feet may point to creative power.

Kifwebe Mask

Color is typically applied to a sculpture's raised or incised areas. The use of white paint on this mask enhances its three-dimensional quality. This mask belonged to a men's association and was used in chiefs' funerals. *Luba people, Zaire. Wood, pigment. Collection of Richard Hunt. Photograph courtesy of Vesta Daniel.*

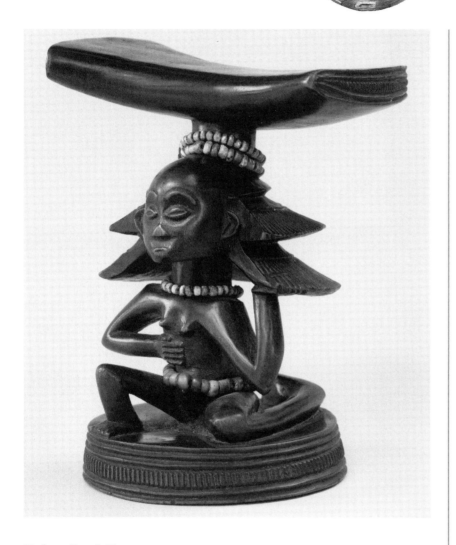

Neckrest: Female Figure

This neckrest, used by Luba men and women to protect their elaborate hairstyles, is stable but dramatic. The triangular spaces under the arms of the piece repeat the shape of the coiffure and become part of the design. Symmetry is broken by the opposing position of the hands. In real life, the cascade hairstyle, worn by both men and women, was built up with supports of thin wood woven into the hair. *Luba Shankadi, Zaire, 19th–20th century. Wood, beads, 5 ⅛ x 6 ⅛" (13 x 16 cm). Courtesy of The Metropolitan Museum of Art, Gift of Margaret Barton Plass, in honor of William Fagg C.M.G., 1981.*

Introduction

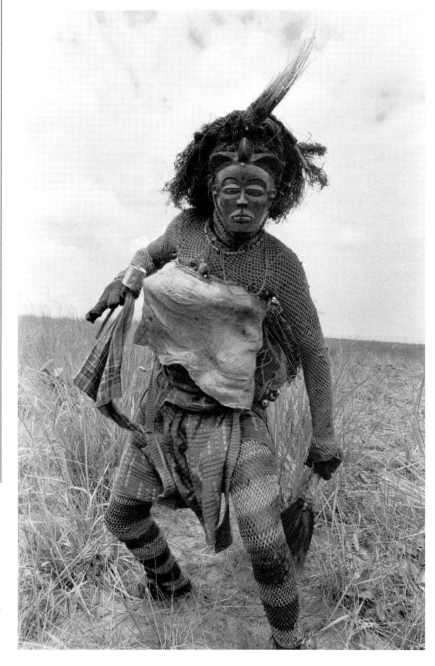

In Africa, sculptures that are hidden from view are said to have more spiritual potency than those that are highly visible. A person may interfere with the effectiveness of the object if it is visible, or it may bring harm to the person. Traditionally and today empowered sculptures are rarely displayed except in museums; they are not meant to be studied for their artistic value. Instead, they are hidden in small chambers and shrines, clothed and placed in containers made from gourds, or pots, or buried in the ground.

Altarpiece
In contrast to Western sculpture, many African sculptures were meant to be seen by only a select few or by nobody at all. Among the Dan of Liberia, certain types of statues were wrapped in a cloth and kept in the owner's rooms. Note the smooth, polished idealized human face. *Dan people, Liberia. Wood, cloth, hair, fiber, shells, 20" (51 cm). Courtesy of Charles Mack.*

Dancer Wearing Mwana Pwo Mask
This mask was used by a traveling entertainer in the Pende area of Zaire. The costume consists of a knitted garment that covers the dancer's body completely. The dancer tops this with a loin cloth. *Courtesy of the National Museum of African Art. Photograph by Eliot Elisofon, 1970.*

Masks, by contrast, were meant to be seen. Ritual masks were held as sacred objects and used in religious ceremonies for the purposes of cleaning, honoring or blessing. According to stories told generation after generation ritual masks represent spirits that live in the forest. The untamed wilderness represented one of two realms (the second was the civilized realm, marked by village boundaries) which typified the belief of traditional cultures. One of the objectives of masquerade was to manipulate and calm the untamed forces. The mask and costume were used to absorb the life force of the mythical being that was represented, and protected the wearer from its power and other evil forces. While women rarely performed in mask rituals (women in the Sande society were exceptions), several African myths report that mask rituals were initially discovered and danced by females. Since it was traditionally believed that the masquerader represented a spirit, the body of the masked dancer was covered from head to toe with a fiber or cloth costume.

Performance masks are not meant to be viewed in a museum setting, but in the play or the dance for which they were made. When we view a mask in isolation we are missing two-thirds of the art—the costume and the music or words that accompany the performance.

Many of the traditional ritual masquerades are used today to entertain tourists. For example, a version of the Mwana Pwo masks, once used to represent a mature woman who had proven her fertility by having children, is now used to mock various female personalities. Acrobatic and stilt dancing also provide contemporary entertainment.

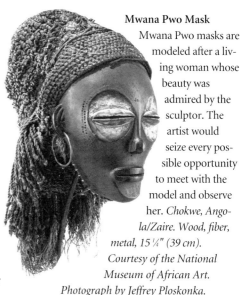

Mwana Pwo Mask
Mwana Pwo masks are modeled after a living woman whose beauty was admired by the sculptor. The artist would seize every possible opportunity to meet with the model and observe her. *Chokwe, Angola/Zaire. Wood, fiber, metal, 15 ¼" (39 cm). Courtesy of the National Museum of African Art. Photograph by Jeffrey Ploskonka.*

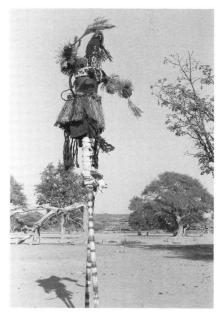

Stilt Dancer with Mask of Fulani Woman
Stilt dancers often appear at the end of a ceremony or ritual to ease tension, or simply to entertain. They perform acrobatic feats on tall stilts ten to fifteen feet above the ground. The masks worn during these occasions did not frighten women and children. This dancer carries a whip of dried grasses in each hand and emits sounds. *Courtesy of the National Museum of African Art. Photograph by Eliot Elisofon, 1970.*

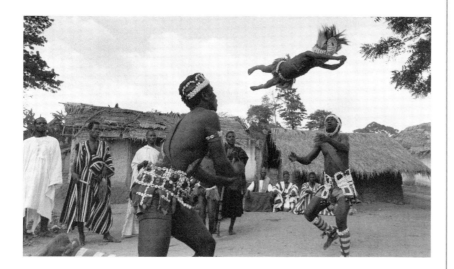

Acrobatic Dancers
Acrobatic dancing is very popular in Africa, and very entertaining. *Dan people, Man region, West Côte d'Ivoire. Courtesy of the National Museum of African Art. Photograph by Eliot Elisofon, 1971.*

Chapter 1

ART FOR LIFE

*T*he importance of birth to Africans can be seen in the rich variety of sculptures they make about it.

In most African societies south of the Sahara, art was closely connected with the cycle of life. Birth, maturity and death were all marked with finely crafted artworks. Of these events, the beginning of life had special significance, for only through the birth of children could the family line—and the welfare of the community—be preserved. Because they helped at home and in the fields and took care of the elderly, children were valuable. To have many children made a family rich indeed.

The first birth—that of the founding couple—was especially important to traditional Africans. Like Adam and Eve, the founding couple of a culture was made up of the man and woman who were believed to have given life to the ancestors of a particular ethnic group. While the details vary, most African societies have creation myths that explain the origin of their societies. According to the Dogon people of Mali, for example, the first man and woman gave birth to a series of twins. These twins were the first of the original eight ancestors of the Dogon tribes. The Dinka of the Sudan say the first man and woman were small figures made from clay and placed in a pot. When the pot was opened they became big. The Ashanti of Ghana believed that the first ancestors came to the surface through holes in the ground.

Sculptures portraying symbolic couples are found throughout many parts of sub-Saharan Africa. Made from iron, wood, ivory and terra-cotta, they measure anywhere from a few inches high to over six feet tall. While the male and female figures generally share a strong resemblance, there is usually something that distinguishes the genders. For example, the female figure, represented in the Edan couple of the

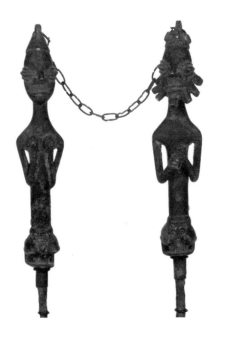

Edan Couple
This sculpture represents the primordial couple of the Yoruba people, and has an interpretation similar to that of Adam and Eve. Notice the long elegant forms that emphasize the vertical thrust of these figures. The sealed lips of the figures are a sign of seriousness, and the swollen eyes were thought to accommodate the inner eyes of God. *Yoruba people, Nigeria. Brass, 9 ¼" (23 cm). Courtesy of Charles Mack.*

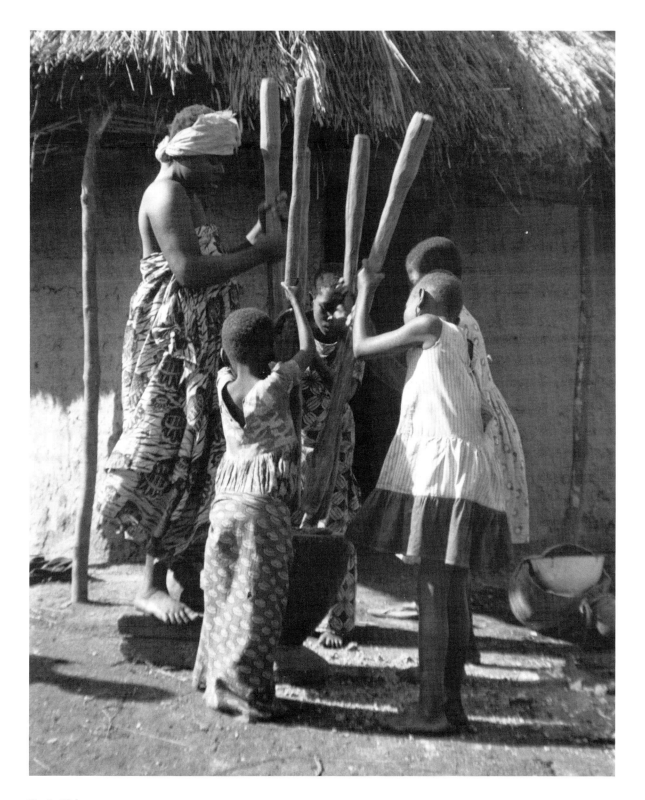

Konjo Girls
At an early age, children participated in daily life by helping their parents and relatives. These girls are pounding cassave (a root vegetable) in a mortar. *Rutshuru, Zaire. Courtesy of the National Museum of African Art. Photograph by Eliot Elisofon, 1970.*

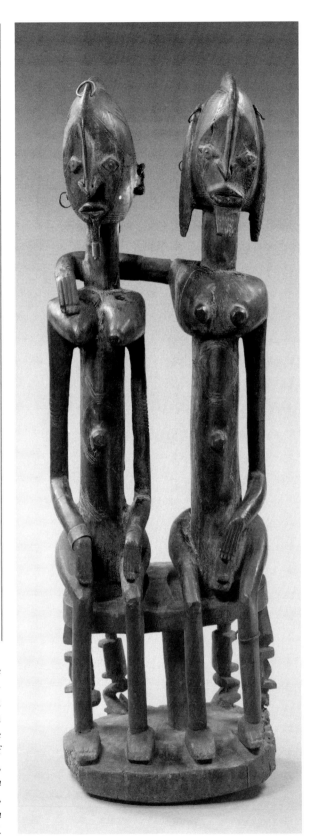

Dogon Couple
The vertical and horizontal forms of this sculpture are linked together to reflect how Dogon men and women depend on one another. Both forms are alike, except the woman may be identified by her labret (an ornament made of wood or bone worn in a pierced lower lip), which nicely balances the man's beard. *Dogon people, Mali, 19th–20th century. Wood, metal, 28 ¼" (73 cm). Courtesy of The Metropolitan Museum of Art, Gift of Lester Wunderman, 1977.*

Yoruba people from Nigeria may cross her hands over her chest in the traditional posture of respect, while the male figure's hands are uncrossed. Females in other cultures are often distinguished from the male by the presence of a child.

Couple sculptures were used in many ways and may have one or more functions. They may call forth ideas about fertility. Those of the Dogon of Mali are symbols of historical or mythical beginnings. Some suggest a belief in male and female equality, while others may function in the divination process. Still others are used to cure diseases and purify a village of evil forces.

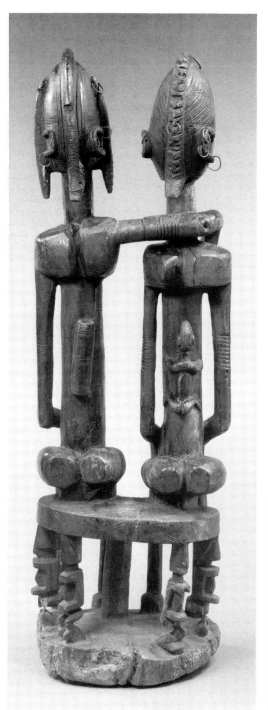

Back View of Dogon Couple
The child on her back distinguishes the mother in this view of the sculpture. The man's quiver represents his role as a hunter or warrior.
Dogon people, Mali, 19th–20th century. Wood, metal, 28 ¾" (73 cm). Courtesy of The Metropolitan Museum of Art, Gift of Lester Wunderman, 1977.

Art for Life

Fertility

Children represented wealth and prosperity in early African society. They were thought to be a blessing from the spirit world. An African could be rich, but without children he was considered a most unfortunate person.

As recently as a generation or two ago, fewer than half the pregnancies of African women produced living children. The desire for frequent pregnancies—and healthy births—influenced the production of a variety of artworks. Often called fertility figures, these sculptures usually portray a child, a mother and child image or a mature woman. They suggest the childbearing powers of women, and either represent a plea for a child or thanksgiving for the birth of a long-awaited child. A woman might have a fertility image carved for her if she had been childless or to ensure safe delivery of an unborn child. The Akan, for example, made wood carvings called *akua'ba*, which represented the ideals of physical and spiritual beauty of the child-to-be. By carrying an akua'ba, around with her, and by bathing and oiling it, an expectant mother believed that the beauty of the statue would be given to her child.

The earliest known mother-and-child statues come from the Nok culture, which dates from the first millennium B.C. These and later mother-and-child sculptures are usually presented in a kneeling or seated position, with the child placed on the legs of the mother, held in the mother's arms or hugging the mother. Unlike similar medieval- and renaissance-period images, the mother and child in traditional African sculptures show no signs of emotional exchange. This is probably because the sculptures are intended to illustrate abstract ideals, such as childbearing, fertility or feminine beauty, and not the emotional experience of motherhood.

Akua'ba
This figure is made up of simple geometric shapes. The high forehead and small features were characteristics desired by African mothers. The neckrings represent health and well-being.
Akan people, Ghana. Wood. Collection of Joseph Floch.
Photograph by Arthur Efland.

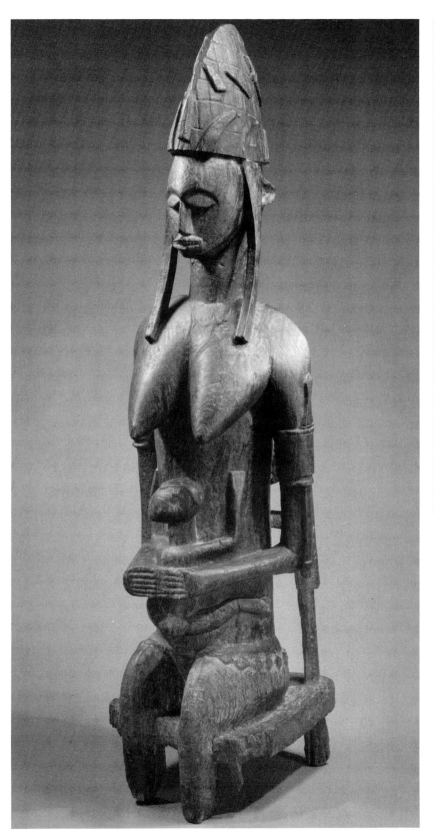

Akua'ba
While the head of this fertility sculpture is traditionally disc-like, the body is fairly realistic. *Akan people, Ghana. Wood. Courtesy of Charles Mack.*

Gwandusu Statue
A heavy chest and thighs give strength to this seated mother. Note how your eye is led down the form by the braid-like extensions of the headdress. This type of fertility sculpture would have been displayed in a group including a father and several other male and female figures. *Bamana people, Mali, 19th–20th century. Wood, 48 ⅜" (124 cm). Courtesy of The Metropolitan Museum of Art, the Michael C. Rockefeller Memorial Collection, Bequest of Nelson A. Rockefeller, 1979.*

In many African societies, elderly women of the royalty who were past childbearing days were thought to be at the height of their power. These ancient mothers were honored and feared. Often they held the position of honorary adviser or honorary mother of the kingdom. Images of great or ancient mothers are usually identifed by the presence of a royal chair or stool; sometimes the feet of the figure are elevated. Often the women have linear or pictorial scars called scarification marks. These marks, which are cut intentionally, represent maturity, beauty and health, and identify the woman as a socialized and civilized member of the community.

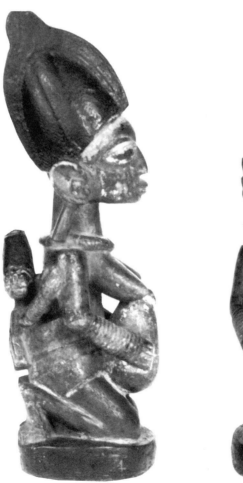
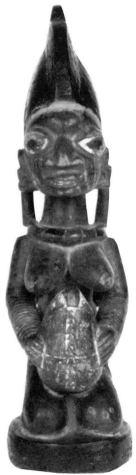

Altarpiece
This polychrome kneeling figure holds an offering of fruit or eggs. Because she has scarification marks on her cheeks, we know she is a mature woman. She symbolizes fertility and the continuation of the family. The elegant hairstyle identifies her as a socially responsible, educated person. *Yoruba people, Nigeria. Wood, 17 ½" (44 cm). Courtesy of Charles Mack.*

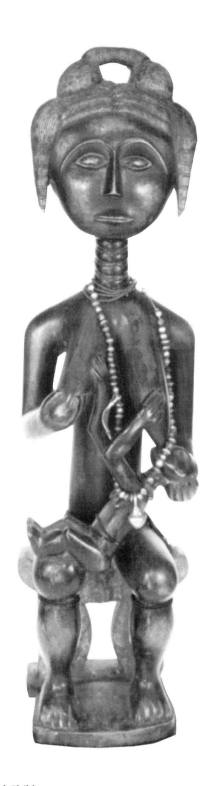
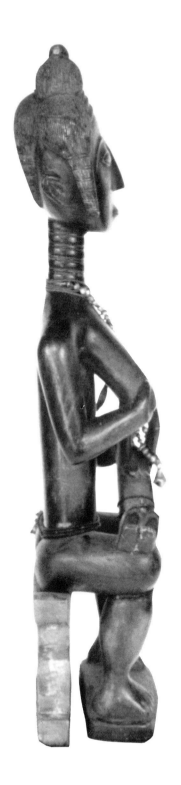

Mother and Child
Queen mothers are typically shown seated on stools or chairs, holding a child and adorned with jewelry. This mother wears beads and a gold-plated necklace around her ringed neck, a sign of health and wealth. Note her stiff, upright pose. *Akan people, Ghana. Wood, 22 ½"* *(57 cm). Courtesy of Charles Mack.*

Art for Life

Virility

*P*owerful men were the backbone of strong families and communities. A man's masculinity, or virility, was therefore as important to traditional African cultures as a woman's fertility.

Every civilization has its own ideas of what represents maleness. In traditional African societies, the ultimate male was a hero-like figure who had the spiritual, mental and physical energy to overcome all challenges. Most typically, these heroes were powerful hunters, warriors and chiefs. The heroes—and the myths and legends surrounding them— were portrayed in various works of art laden with imagery symbolizing spiritual, mental and physical powers. These images included quivers, daggers, guns, spears and trophies. Particular hairstyles or headdresses, facial scarification marks, jewelry, fine dress and containers holding medical ingredients were also symbolically used.

One popular hero was Chibinda Ilunga. The strength and power of this legendary hunter/warrior were celebrated in artworks by the Chokwe of Angola and Zaire. According to myth, Chibinda Ilunga

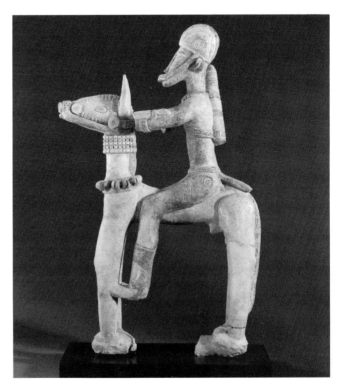

Djenne Equestrian Figure
The forms of this rider and horse appear to have been modeled from coils of clay. The decorations on the fancy uniform and the horse's collar are engraved. The rider's formal stance conveys the image of a heroic leader. *Mali Inland Delta Region, 13th to 15th century. Fired clay, pigment, 27 ½" (70 cm). Courtesy of the National Museum of African Art. Photograph by Jeffrey Ploskonka.*

brought together two tribes, the Lunda and the Luba, in the sixteenth or seventeenth century. He did this by marrying the daughter of a Lunda chief. Chibinda Ilunga also introduced advanced hunting techniques and established a political system arranged by hierarchy. In short, he was the bearer of new cultures. Chibinda Ilunga's image is carved mainly as a reminder of the ideal qualities of a hunter/warrior: his beard symbolizes wisdom, his weapon shows hunting prowess, his headdress is a sign of chieftaincy, and his enlarged hands and feet emphasize his physical strength.

Figures of men on horseback were also used by many traditional West African cultures to glorify the lives of their leaders, heroes and warriors (the horse is not native to West or Central Africa, but was imported from the north around 1000 A.D.). Because of changing times, today the importance of the horse as a symbol of power and status is much reduced. Instead, success and power are often expressed in contemporary artworks by such objects as European-style hats and clothing or a briefcase.

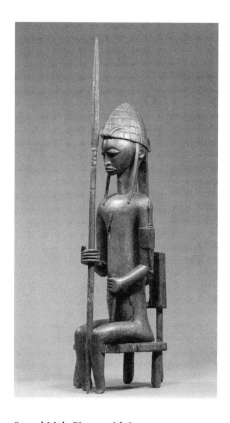

Baule Figure
This slender figure wears a Colonial uniform and helmet. His face lacks scarification marks. In the 1950s, this image represented ideals of power and prestige to many people of the Baule culture. It clearly shows a shift in social and economic values. *Baule people, Côte d'Ivoire. Polychromed wood, 12 ⅝" (30 cm). Courtesy of Charles Mack.*

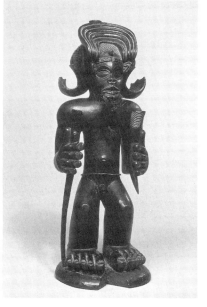

Agere Ifa
This cup which is dedicated to Ifa, the Yoruba god of divination, holds palm nuts used to predict the future. It was originally polychrome with touches of indigo, red and brown. It is supported in the center by a rider on horseback. Note how the hairstyles of the surrounding figures point to the rider. *Yoruba people, Nigeria. Wood, pigment. Courtesy of Charles Mack.*

Chibinda Ilunga Katete
Notice the swelling forms of this hunter's arms and legs. The flexed leg stance, the presence of the headdress, weapons and hunting bag all confirm his cunning, hunting ability and chiefly status. *Chokwe people, Angola, 19th century. Wood, 5 ¼ x 15 ¼ x 5 ¼" (15 x 41 x 15 cm). Courtesy of Kimbell Art Museum, Fort Worth, Texas.*

Seated Male Figure with Lance
This hunter carries a spear and a horn. A dagger is attached to his arm. All these objects signify power. Note that this sculpture would be grouped with the Gwandusu Statue on p. 21. *Bamana people, Mali, 19th or 20th century. Wood, 35 ⅜" (88 cm). Courtesy of The Metropolitan Museum of Art, Gift of Kronos Collections, in honor of Martin Lerner, 1983.*

ART FOR PERSONAL POWER

*T*he well-being of an individual is believed to be determined by a vital force in his or her blood. A person can increase this force by creating a bond with the spirit world through prayer and offerings. The stronger the bond, the richer they become.

Some African societies believe that a person's fate is controlled by his or her behavior throughout life. Others believe that fate is controlled partly by the person's behavior and partly by the spirit world. For example, among the Yoruba and Igbo peoples of Nigeria, the wealth of a rich person is credited to both fate and personal success.

In many African societies there is little that separates the rich and the poor. Rather, people are required to share with each other for the good of the community. In societies governed by royalty, like the Yoruba, wealth can exist, but even the wealthy are obliged to share with others.

Objects representing the amount of power a person has include altars or shrines, masks and statues. Altars or shrines are usually made of natural objects ranging from earth mounds to forked sticks. Generally, a person will have only one altar or shrine. Masks and statues are fabricated. Statues can be schematic or naturalistic figures, and can sometimes be considered altars or shrines themselves. Other objects of empowerment may include charms and talismans, which are believed to be magical. It is said they have powers of their own, which can protect an individual or cause an aggressive act.

Dan Mask
Miniature masks of this sort were used in Liberia as charms to protect the owners. *Dan people, Liberia. Wood, fiber, cowrie shells. Collection of Richard Hunt. Photograph courtesy of Vesta Daniel.*

Artworks used for personal power are commissioned upon the advice of a diviner, and are usually a number of artworks associated with each one. Some are curative figures used to heal the sick or rid them of problems. Others are preventative figures used to fend off misfortune. People pray and make offerings to the objects because they believe the objects will capture the power of the vital forces that will come and feed there.

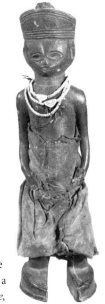

Female Figure
This female figure was probably a part of a personal altar. It wears a protective necklace and is wrapped in a cloth. *Luchazi people, Zambia. Courtesy of the Livingstone Museum.*

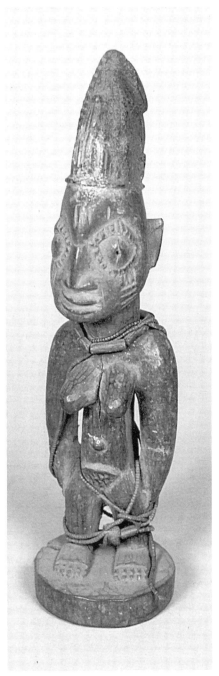

Ibeji **Figures**
Yoruba *ibeji* figures were often kept in domestic altars or stored in calabashes (containers made from gourds) as a representative of divine force. *Yoruba people, Nigeria. Wood. Collection of Richard Hunt. Photograph courtesy of Vesta Daniel.*

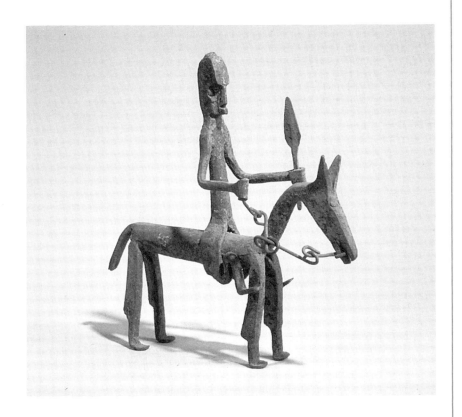

Equestrian Figure
Bronzes of West Africa were frequently used by individuals as protective, curative or commemorative devices. *Bamana people, Mali. Metal. Collection of Richard Hunt. Photograph courtesy of Vesta Daniel.*

Art for Personal Power

Divination

*B*ad luck in hunting, crop failure, or death of a child was believed to be caused by witchcraft or the neglect of an ancestor. A person could ask a diviner for help in finding out why and solving the problem through psychic methods.

Far more than a fortune teller, a traditional African diviner was part therapist, part doctor, part philosopher and part priest. Diviners, who could be men or women, were called to the profession by their ancestors, usually at a mature age. People receiving the call usually experienced an illness or misfortune. For example, a man may have had several accidents while hunting. When he talked to a diviner, he may have found that the accidents represented his calling to the profession. After receiving the call, it was necessary to train for many years under

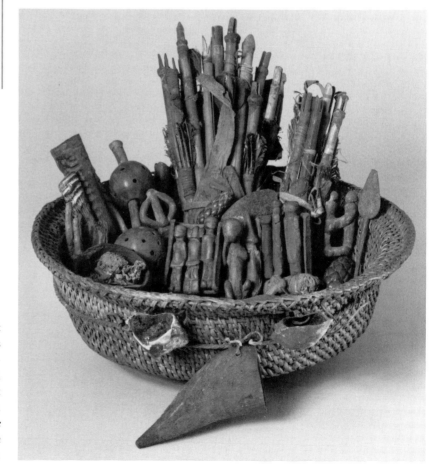

Hamba Basket
This basket contains a variety of carved images and found and natural objects used for divination. All the items have symbolic values which are linked to daily life, religion and witchcraft beliefs. *Chokwe people, Zaire and Angola. Fiber, various materials, 15 ¾" (40 cm). Courtesy of the National Museum of African Art. Photograph by Jeffrey Ploskonka.*

an experienced diviner. At the end of the training, the new diviners were tested. The Ndembu diviners of Zambia, for example, were required to demonstrate the clarity of their psychic powers by finding lost objects.

Some diviners worked through the spirit possession. A person was possessed when his or her body was occupied by a spirit. The person would trance and faint. The trance was controlled with prayers, body motion and certain drinks. The person then represented the spirit until the end of the ceremony. Other diviners used a variety of specialized objects to determine the cause and solution of a problem. The Chokwe diviners of Angola and Zaire, for example, used a basket containing around sixty objects, including figurines, tools, bits of metal, feathers and animal horns, hooves, claws and bones. After blowing tobacco smoke, the diviner would shake the basket while asking questions of the client. After some singing and chanting, the diviner would give the basket a great shake. He would then "read" the pieces that fell to the edge of the basket for the solution to the problem.

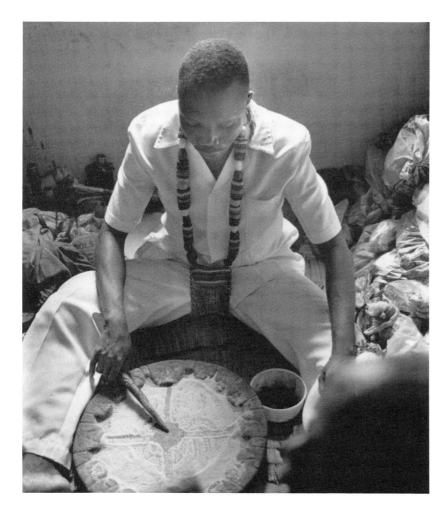

Kolawole Ositola, a Yoruba Priest of Divination
As this priest rhythmically taps on the center of his divination board, he appeals to the ancient Ifa priests and the spirits whose powers are necessary for the success of the ritual.
Courtesy of J. Pemberton.

By contrast, Yoruba diviners read the patterns created by sixteen palm nuts manipulated on a round, rectangular or half-moon-shaped board. The patterns referred to verses that the client would then chant to cure the problem.

Yet another type of divination object was the friction oracle, or itombwa, used by the Kuba of Zaire. These small wooden animals or reptiles were used with an oil- or water-soaked disc or knob, which the diviner would rub across the back of the carving while repeating possible cures for an illness or solutions to a problem. When the correct cure or solution was named, the disc would stop moving. As a final test, the diviner would turn the carving upside down. If the disc remained in place, the cure or solution was known to be correct.

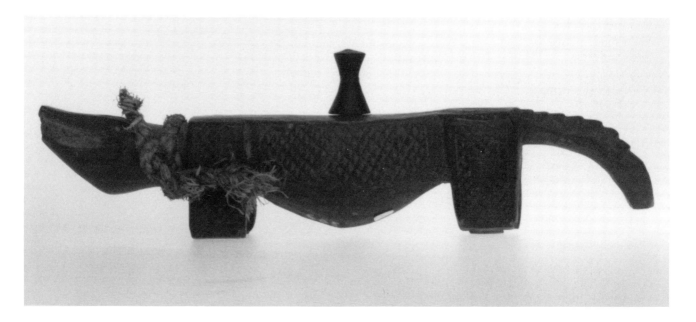

Friction Oracle
These small wood carvings were shaped like various symbolic animals and lizards. The crocodile shown here represents patience. Note how the raised triangular patterns on the sides contrast with the flat, smooth back. *Kuba people, Zaire. Wood, 2 ¼ x 15 ¼ x 3 ⅛" (6 x 39 x 8 cm). Courtesy of Charles Mack.*

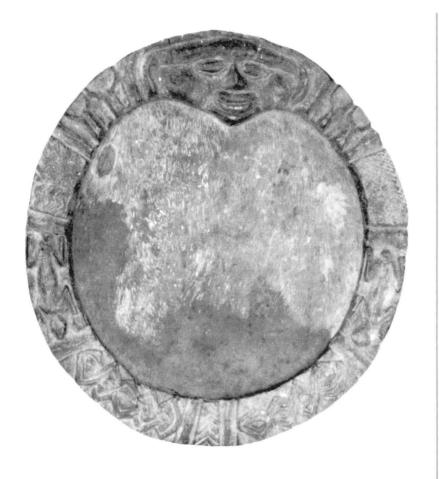

Circular and Rectangular Divination Boards
The elaborately carved border of divination boards always depicts the face of Eshu, the messenger of Olorun, the sky orisha (an orisha is a deity that represents any one of the natural elements). Birds, lizards and decorative motifs add further interest to the borders of these boards. *Yoruba people, Nigeria. Wood. Courtesy of Charles Mack.*

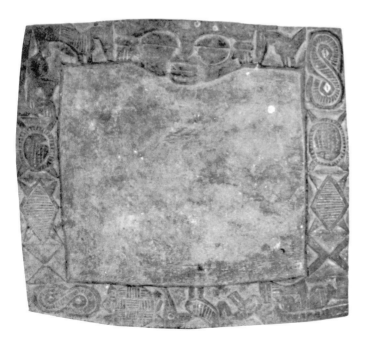

Symbolic Statues

*I*ndividuals often had special statues of spiritual beings carved for them. For success or trying to end misfortune, a person prayed or made offerings to these spirit statues.

Not all troubles plaguing Africans were thought to be caused by witchcraft or ancestor spirits. Some problems were believed to be created by other types of neglected spirits. These spirits represented life forces from the bush who imitate nature. They may live in the rivers, trees or rocks. They are considered angry and dangerous. To calm the spirit, a diviner might recommend that a statue be carved to honor it. This statue would be kept in a personal shrine, that is, a special container or place, in a safe part of a room. The owner would take every opportunity to honor the spirit to be calmed by the statue.

Statues made to honor the spirits varied in complexity from very schematic to intricately carved. Among the most beautiful of the detailed figures are the spirit spouses carved by the Baule of the Côte d'Ivoire. According to Baule mythology, before a person was born on earth, he or she had a spirit spouse. Unless the earthly spouse honored the spirit spouse, the spirit spouse could cause misfortunes ranging from infertility and the death of a child to business failure. Statues of spirit spouses were always beautiful, carved to represent the ideal husband or wife. They were kept on an altar, and frequently washed and tenderly handled.

Depending on the spirit, sometimes sacrificial offerings were prescribed by the diviner. Among the Baule people of the Côte d'Ivoire, for example, owners of statues representing nature spirits often threw substances such as raw egg, chicken blood and herbal medicines upon the statue. The buildup of sacrifices upon the statue caused it to become encrusted and dirty thereby increasing its vital force for better control of the spirit.

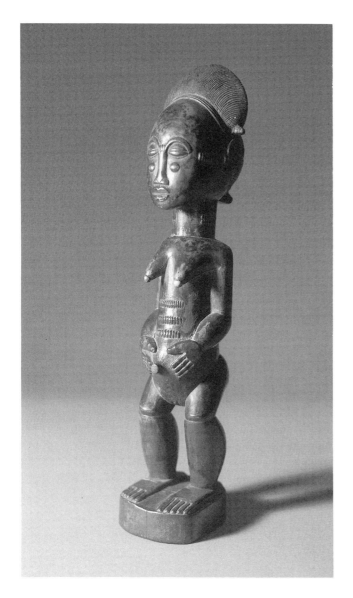

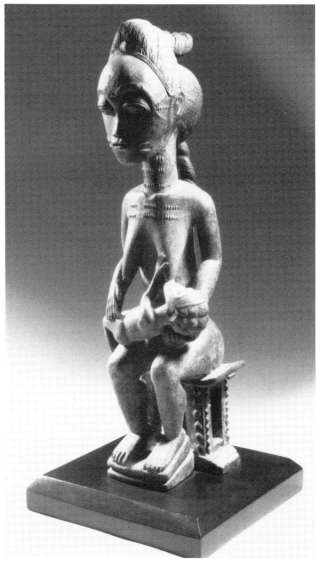

Spirit Spouse

This naturalistic statue is made up of well-defined, bulging forms. The large calves define a hard-working individual while the details of the hair, face, and body represent the maturity of a person who has completed initiation. Scarification marks indicate the physical and moral beauty of a human being. The mouth is small and the eyes have delicately carved lids. *Baule people, Côte d'Ivoire. Wood, 4 x 19 ¼" (10 x 49 cm). Collection of Joseph Floch. Photograph by Arthur Efland.*

Nature Spirit

This female sits on a stool while she nurses her child. Notice the crust of sacrificial offerings on the surface. Note how the strong vertical line of the statue is broken by the diagonal form of the child. *Baule people, Côte d'Ivoire. Wood. Collection of Joseph Floch. Photograph by Arthur Efland.*

Sometimes a person would hire someone to make statues and charms, called amulets, for him or her to ward off misfortune or to ensure personal success. A large compound in which to live, a high rank in the social order, a bountiful yam harvest, many wives and children and numerous livestock were all emblems of success. For example, the Kalabari Ijo men of southeastern Nigeria kept Ikenga figures. Many of these figures depict a horned man seated on a stool—the horns represent force and aggression. In the left hand the figure holds a drawn sword; in the right he holds a human skull symbolizing bravery or an elephant skull for wealth.

Ikenga figures were not owned by women. Among the Igbo of Nigeria, for instance, woman's success was tied to childbearing, as opposed to the characteristics suggested by the Ikenga figure. Ikenga figures could either be kept in a man's home, or, if owned by the community, in the common meeting house. Usually a man would obtain an

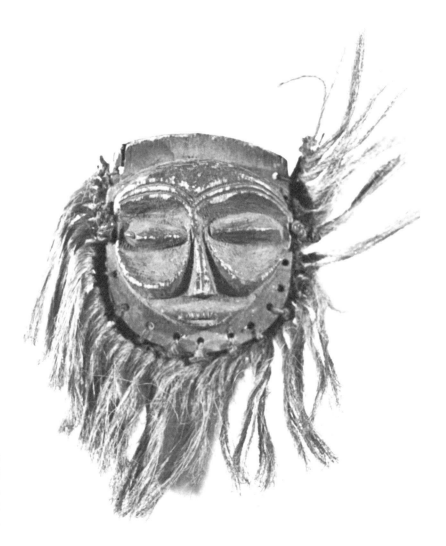

Nkishi Amulet
This miniature mask serves as an amulet to ward away evil. It was probably carried by hunters. *Ndembu-Lunda people, Zambia. Wood, fiber. Courtesy of the Livingstone Museum, Zambia.*

Ikenga figure about the time he was ready to raise a family. A newly acquired Ikenga was blessed by a priest, and its owner "fed" it daily with palm wine and kola nuts. On important occasions, such as annual ancestral festivals, weddings or funerals, or at the start of a major personal venture, animals were killed and their blood sprinkled on the Ikenga.

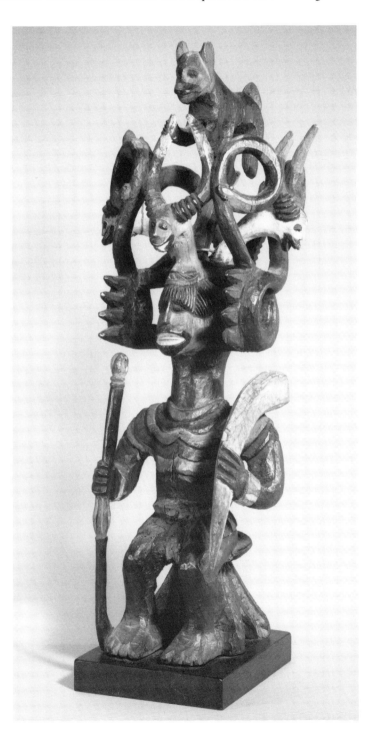

Ikenga
Ikenga statues are meant to be seen from the front, and must be positioned so they have facial contact with their owners. The back, therefore, has simpler carving. The intricate open work produces gaps that give the figure a rhythmic movement. *Igbo people, Nigeria. Wood, pigment, 24" (61 cm). Courtesy of Indiana University Art Museum.*

Chapter 3

ART FOR
NATURE & SOCIETY

*A*fricans used artworks to help keep the community safe, peaceful and well fed. Sculptures and masks were used in hunting and fishing ceremonies to help ensure the food supply.

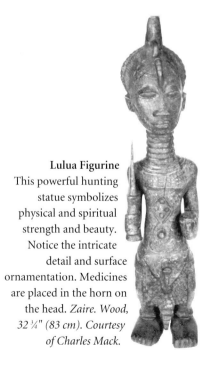

Lulua Figurine
This powerful hunting statue symbolizes physical and spiritual strength and beauty. Notice the intricate detail and surface ornamentation. Medicines are placed in the horn on the head. *Zaire. Wood, 32 ¼" (83 cm). Courtesy of Charles Mack.*

The way a community gathered its food influenced the type of artworks produced. Africans in the woodland areas used hunting images, while lake and delta residents used fishing images. The artworks of the farmers of the grasslands and plain areas reflected their dependence on and respect for the cycles of the seasons.

The needs of the hunter were met by honoring the spirits of the forest. Traditionally, hunters performed a ritual both before and after a hunt. The Lulua hunters of Zaire, for example, guaranteed a successful hunt by placing a dog's snout and some hyena teeth in the head of a figurine—the snout symbolized the ability to smell the game, and the hyena teeth represented luck. The figurine was then placed on a mound of earth while the hunters were away. Individual Lulua hunters also wore miniature figurines as companions during the hunt. The Chokwe people of Zambia made a hunting shrine out of mud in the form of a leopard, and painted it with white and red spots. When hunters returned from hunting they sprinkled the blood of the slain animal on the shrine.

Fishing communities were often classified with hunting cultures because they both freely helped themselves to nature's bounty. The ceremonies conducted by fishing peoples honored the water spirits and asked for their help in ensuring a plentiful catch. Masks were often used in these rituals. The Kalabari Ijo people of Nigeria, for example, staged a dance performed by the Ekine society, the most important institution of their village. The society is a male association responsible for the religious, political and recreational aspects of the community. The performers used an *Otobo,* or hippopotamus, mask to appeal to the spirit of the water called owu; the performance it was used in was believed to help fertilize the waters for successful fishing expeditions. In between these ceremonies, which were performed every twenty-five years or so, the mask was stored in a secret storage place. Before use, the old paint would be stripped off and the mask would be washed, repainted and adorned with feathers and pieces of cloth for its new performance.

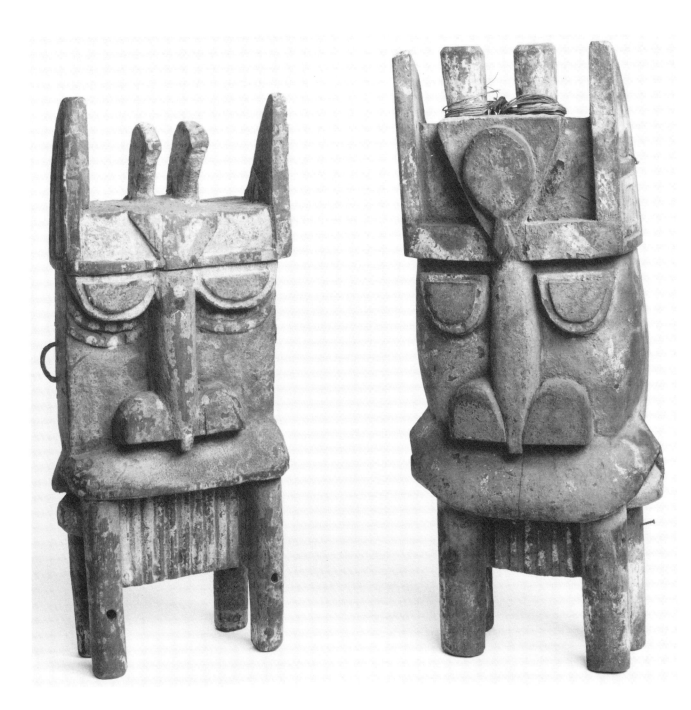

Otobo Mask

Because the Kalabari Ijo people believed that the spirits were half-human and half-animal, this mask combines both human and animal features. It is worn horizontally, so that the face of the mask is directed toward the sky—the place where spirits reside. Notice the contrast and repetition of angular and rounded forms. *Kalabari Ijo, Nigeria. Wood. Courtesy of the British Museum.*

Farming

*F*armers were revered in African society. They lived on their land a long time and used many forms of art to make sure their plantings and harvests were successful.

The cycle of the growing season follows the cycle of birth and death. At the beginning of the planting season it was therefore important for traditional African societies to honor the creators, founders or heroes that gave birth to their communities. This could be the master of the land or the mother of the earth. Other important events were the tilling of the soil, the sowing of the crop, the period just before the rains and, finally, the harvest. Frequently these were celebrated with rituals using masks and statues. Rituals were also performed during periods of catastrophe, such as drought, flood, famine and disease.

Ritual farming sculptures usually either represented the hero who taught the people how to farm or a deity of the earth. The chi wara, for example, a headdress worn by the Bamana of Mali, represents the mythological being—half-human and half-animal—who taught the Bamana to cultivate the earth. While the style of the headdresses varies, they can usually be categorized as vertical, horizontal or abstract.

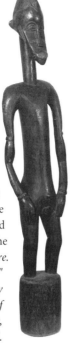

Rhythm Pounder
This statue was used by the Lo society of the Senufo culture during the annual first tilling of the soil. It was pounded against the ground in time to music. Notice the tall elegant form of the figure. The emphasis is on the body and massive shoulders, not on the head. *Senufo, Côte d'Ivoire. Wood, 9 ⅛ x 6 ¹¹⁄₁₆ x 44 ⅛" (23 x 17 x 112 cm). Courtesy of Memorial Art Gallery of the University of Rochester, Marion Stratton Gould Fund.*

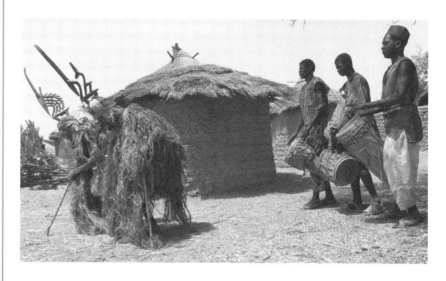

Chi Wara Antelope Dancers
Bent over their sticks, the dancers imitate the leaps and bounds of young antelopes in order to calm the earth spirits and ensure the field's fertility. *Bamana people, Bamako area, Mali. Courtesy of the National Museum of African Art. Photograph by Eliot Elisofon, 1971.*

The headdress is worn with a costume composed of black-dyed fibers fastened to a woven cap. The ritual is performed by pairs of men and women who are members of the Chi Wara Association. Men wear both the male and female headdresses. The two headdresses together represent the union of the sun, earth and water—vital forces needed by plants to grow. The dance is performed when a new field is to be cleared in April and May, and at the time of harvest in October. As the participants dance, female singers praise the virtues of the ideal farmer. Traditionally the Chi Wara ritual was performed as part of a secret initiation, away from women and children, but today it is danced in public.

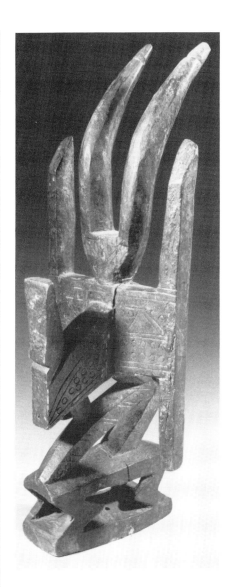

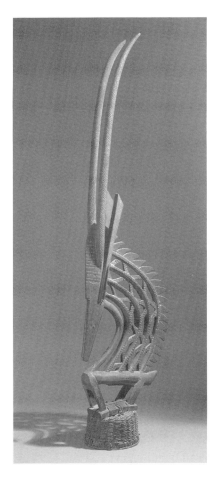

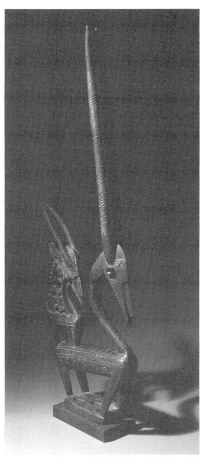

Abstract Chi Wara Headdress
In its abstract form, we see faint curves of the body, the pointed lines of the horns and the sharp outlines of the legs. *Bamana people, Mali. Wood. Collection of Joseph Floch. Photograph by Arthur Efland.*

Vertical Male Chi Wara Headdress
The basket at the base of the headdress fits on the dancer's head. The legs are reduced to emphasize the upper body which is symbolic. The mane symbolizes the sun; the muzzle represents strength; and the horns signify growth. *Bamana people, Mali. Wood. Collection of Joseph Floch. Photograph by Arthur Efland.*

Vertical Female Chi Wara Headdress
The difference between the male and female headdress is the absence of the mane. The female headdress represents the earth and the tilled field. The two combined enable the growth of crops. *Bamana people, Mali. Wood. Collection of Joseph Floch. Photograph by Arthur Efland.*

The Baga of Guinea used an enormous fertility mask, representing a deity of the earth called a *nimba*, for their agricultural ceremonies at planting and harvesting time. The nimba mask was used in the Simo Society, an organization responsible for the initiation of young men, the funerals of elder members and the planting and harvesting of rice. The mask was worn in a procession twice a year, and the women threw rice over it.

In many cultures, the buildings, or granaries, where the harvested grain was stored were of great importance. Much attention was usually paid to their design. Most were made of puddled mud with thatched roofs. Of special importance were the door and lock of the granary, because these were the points of entry to the food supply. A number of ethnic groups, such as the Senufo of the Côte d'Ivoire, the Bamana of Mali and the Dogon of Mali, made elaborate granary locks and doors. Dogon granary doors, for example, frequently refer to the beginning of humanity. There are often figures carved in relief that represent the eight ancestors of humankind. Equestrian figures also appear on these doors as a symbol of prestige and power. These depict Hogon, a blacksmith who represents order in the universe.

The lock for the door is often carved in the form of an animal or human that represents an important mythological figure relating to creation or cultural history. But many of the sculptural elements visible on old locks are no longer in use today. They have been replaced with much simpler forms. The break in the production of these locks among the Dogon, for example, followed the widespread conversion to Islam by the community, and the growth in the number of thieves who stole the locks to sell to Europeans.

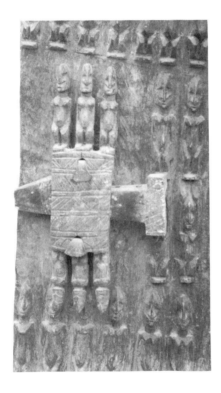

Granary Lock
This beautiful lock, carved by a blacksmith, served to protect the grain. A pair of Nommo figures decorate the top of the lock. The lock is made of three parts: the vertical beam, the horizontal beam, and the key. *Dogon people, Mali. Wood. Courtesy of Charles Mack.*

Nimba **Mask**
This mask was worn over the head and rested on the shoulders of the dancer. It weighs more than eight pounds; when in use, it towers about eight feet off the ground. The form is that of a huge female bust with a projecting face. The costume is completed by a long raffia cloak. *Baga people, Guinea. Wood, 13 ⅞ x 46 ½"* *(35 x 118 cm). Courtesy of Charles Mack.*

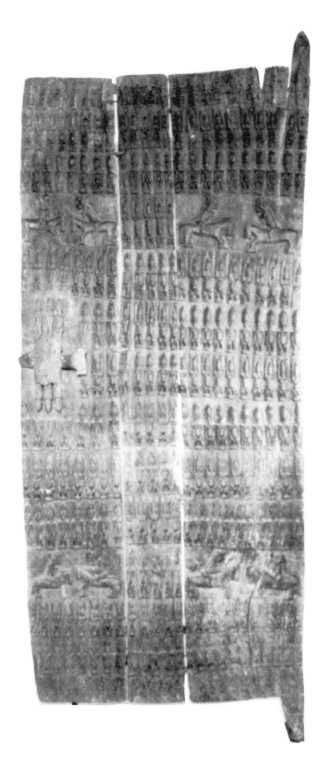

Granary Door
Notice the rhythmic placement of the figures in rows. The top row is lined with crocodiles underneath Nommo figures that are arranged with hands held above the head in every second row. Nommo is one of the sets of twins, sacrificed and brought back to life to reorganize creation. The forms of these figures are almost all the same. *Dogon people, Mali. Wood, 78 ½" (199 cm). Courtesy of Charles Mack.*

Art for Nature & Society

Social Well-Being

African communities used various sculptures as protection from negative forces. They were often used by secret societies, which served to keep order within the community.

Many African communities believed that unexplained deaths, epidemics and other threats were caused by the negative forces. To control these forces, sculptures were commissioned by a group of people or by an individual who was part of a secret society. The objects were often made in secrecy, to the requirements of the client or clients. Items required might include the features of the sculpture, the type of material and the taboos that should be followed during the sculpture's creation. Taboos forbid certain actions, like eating certain foods or saying certain words, among other things. For example, pregnant women of the Ewondo society in Nigeria are not allowed to knot string, because they believe it will cause a difficult birth.

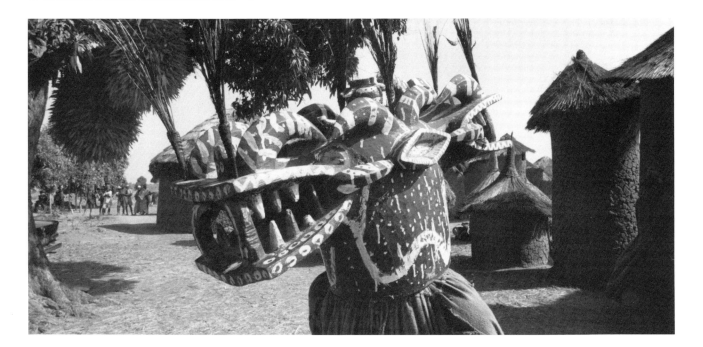

Fire Spitter Mask
The fire spitter gets its name because the dancer roars and emits smoke and sparks from the muzzle of the mask. The performance is accompanied by drums, trumpets and chanting. *Senufo people, near Korhogo, Côte d'Ivoire. Wood, pigment, cloth, grass. Courtesy of the National Museum of African Art. Photograph by Eliot Elisofon, 1971.*

Sculptures were often used to symbolize the authority of a police-man, judge or doctor. For example, the helmet mask of the Poro culture, called the fire spitter, was worn by members of the Korubla Society to impress and terrify. Wearing the mask, a society member could act as a lawmaker, a judge in criminal cases, an overseer of funerals or a purifier of the village.

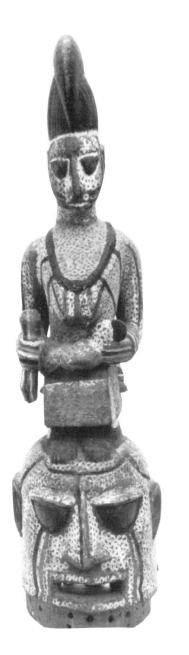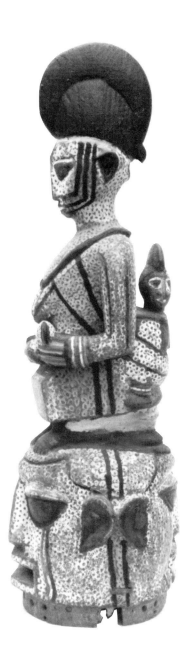

Janus Face Mask
The Janus Face symbolizes supernatural vision in the mortal world and the spirit world. This mask represents a mother with two children. It is used every two years in a festival to ensure the continued fertility and well-being of the society. Such masks are washed and repainted by their owners each time they are used. *Ekiti people, Nigeria. Wood, 46 ½" (118 cm). Courtesy of Charles Mack.*

Secret societies played a major social role in traditional African communities. They were not secret to the community, but they kept secrets from the community, and membership was special. The leaders of the societies were usually the village chiefs. Each society had specific duties to perform—social, religious, political or educational—and each had its own festivals, ceremonies and dances. The Ogboni Society of the Yoruba of Nigeria, for instance, concentrated on the study of law and the punishment of wrong-doers. The Kore Society of the Bamana of Mali was devoted to agriculture.

In theory the societies were open to everybody, but in some cases membership depended on a person's gender or social status. Sometimes secret societies had members from several villages and tribes (such is the case with the Mukanda, a secret educational institution that can be found in Angola, Zambia and Zaire). Members of a society underwent one or several initiations. Each level in the hierarchy had its particular tasks and was accompanied by a special costume, masks or insignia. The secrets of the society were carefully kept from those who were not members.

With the advent of modern ideas, many of the sculptures connected with secret societies have lost or are losing their social and political importance. Masks traditionally used in police rituals and punishment, for example, have largely been replaced by the European system of policing and court procedures.

The Fire Spitter
This helmet mask, carved from a single block of wood, is made up from a series of animal forms. They include the buffalo, wart hog, crocodile and antelope, plus elements of chameleons and birds. The mask is painted with red and white earth colors. *Senufo people, Côte d'Ivoire. Wood. Collection of Joseph Floch. Photograph by Arthur Efland.*

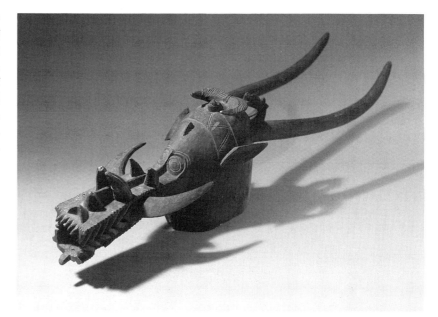

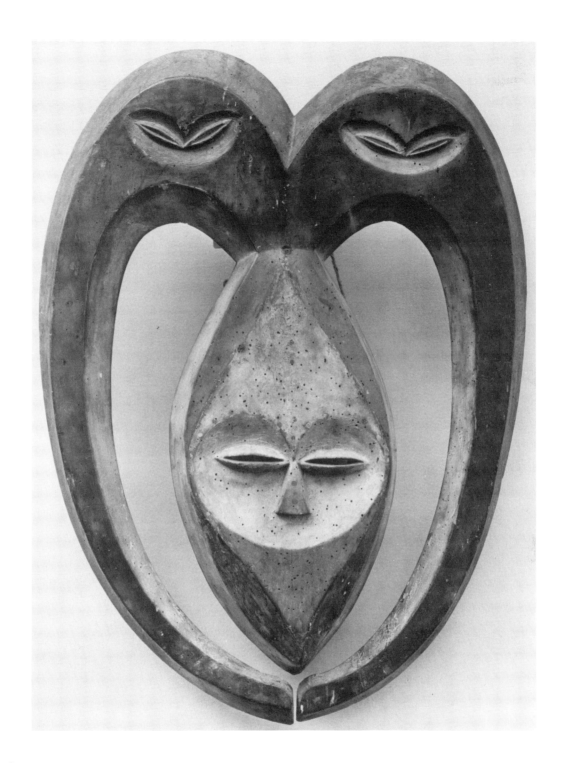

Kwele Mask

This type of mask, used to counteract witchcraft, comes in many styles, always with human and animal features. Here, the heart-shaped humanoid face is painted white to symbolize light and clarity; the horns represent a ram. The ritual in which this type of mask was used involved having all the villagers drink a medicine made from the flesh and intestines of an antelope. The presence of the mask insured the proper atmosphere for the medicines to work. *Kwele people, Congo, Brazza, 19th–20th century. Wood, 20 ¼" (52 cm). Courtesy of The Metropolitan Museum of Art, The Michael C. Rockefeller Memorial Collection, Bequest of Nelson A. Rockefeller, 1979.*

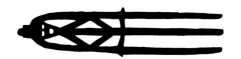

RITES OF PASSAGE

*P*eople pass through many stages from birth to death. For Africans, the most important passages were from childhood to adulthood and from death to the afterlife. These changes were often celebrated with a variety of art objects.

In Western societies, the transition of a child to an adult might be signaled by a special birthday celebration or a high school or college graduation. Some girls are presented to society at a debutante ball or "coming-out" party. Upon death, the deceased would be honored with a wake, funeral, or other ritual. In traditional African culture, both the transition between childhood and adulthood (called "initiation"), and the transition between death and the afterlife would be celebrated by ceremonies called rites of passage. A rite of passage consisted of three steps: separation, seclusion and rebirth. Initiation ended with the rebirth of a child into an adult; death ended with the spirit of the deceased being admitted into the spirit world.

Using ceremonies and rituals, the traditional African educational system prepared the members of its society for these major changes. Education was a community affair. From birth to eight or nine years old, children were closely tied to their mothers and looked to them for most of their needs. Early childhood training, including instruction on

N'domo Dance Mask
Worn in a dance, this N'domo mask shows others in the village that the young man has joined the N'domo Society. *Bamana people, Mali, Bamako region. Courtesy of National Museum of African Art. Photograph by Eliot Elisofon, 1971.*

proper behavior and morals, was conducted informally—through stories told around a campfire or fireplace by members of the extended family, such as grandparents, uncles and aunts. Among the Bamana, for example, the stories, which usually carried a moral lesson, were frequently acted out by puppets. The puppets represented animals, spirits, legendary figures or stereotypes of misers, foreigners or ideal characters. The puppets performed behind a large, mobile, tent-like stage. The stage itself often had a head and a tail, representing an animal, and was moved by a number of dancers. Puppet performances like these were found among such people as the Bamana of Mali, and the Ibo and Ibibio of Nigeria.

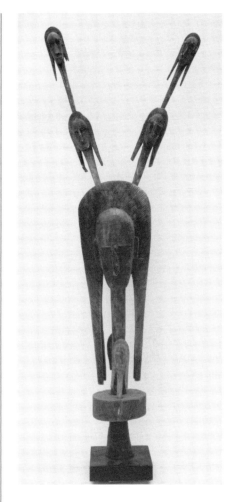

Janus Form Marionette
A Janus form puppet has one face in the front and another in the back. This puppet represents an individual who could be a legendary chief, elder, farmer or musician. The head is put through a hole in the top of a large cloth stage. *Bamana people, Mali. Wood. Courtesy of Charles Mack.*

Marionette
This puppet was probably used by youth groups in nonreligious performances. Its arms and legs were operated by moving rods that were attached to them. *Bamana people, Mali, 19th–20th century. Wood, cotton, cloth, metal, paint, 11 ¼ x 28 ¼" (28 x 71 cm). Courtesy of The Metropolitan Museum of Art, the Michael C. Rockefeller Memorial Collection. Bequest of Nelson A. Rockefeller, 1979.*

Initiation Rites

*B*oys and girls spent many years in initiation. Each part of the initiation helped them understand life and the universe. The end of most stages was celebrated by works of art.

African children, unlike Western children, took on the responsibilities of adulthood at an early age. Around eight years old they began to participate in initiation rites intended to prepare them to function within society. A child's schooling lasted anywhere from two to five years, and was controlled by adult members of the community. These adults usually were members of secret societies.

Initiation has three stages: departure, seclusion and rebirth. During the separation phase the children were taken away from their parents and from the normal activities of the community. Among the Toma of Liberia, boys were captured by the Dandai mask, which appeared to chew and swallow them up. The mask even appeared to have blood dribbling from its mouth. In reality, the boys were hidden under the mask's large fiber skirts; the fake blood came from the dancer chewing kola nuts.

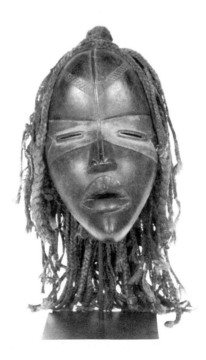

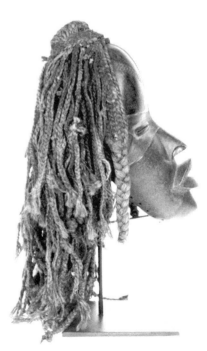

Deangle Mask
Feminine masks such as this one were worn to collect and take food to boys in the seclusion stage of their initiation. The side view presents a more dynamic character. The lips stick out, visually balancing the downward motion of the mop of braided fiber hair. Notice how the naturalistic forms of the face are enhanced by the hair. *Dan people, Liberia, Côte d'Ivoire. Wood, iron, clay, paint, raffia, cowrie shells, 11 ⅜"
(29 cm). Courtesy of Charles Mack.*

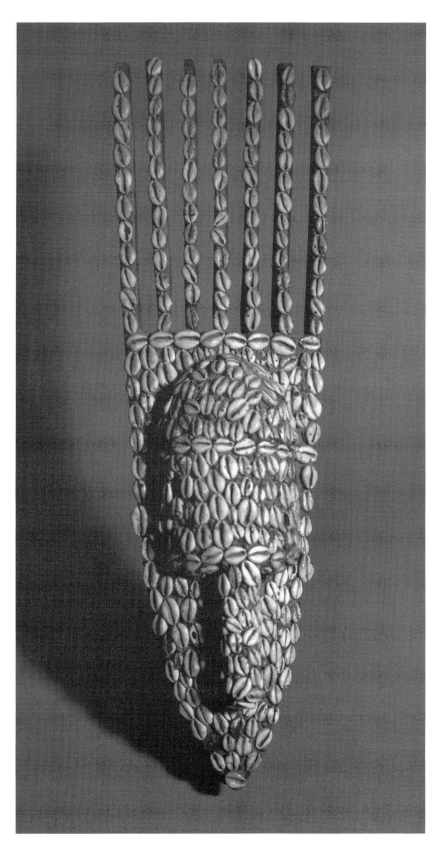

N'domo Mask
This mask is a key part of the first of six initiations, and symbolizes primordial man as an adolescent. N'domo reminds the boys of the first field cleared by human hands after the Bamana abandoned their nomadic life of hunting. *Bamana people, Mali. Wood, cowrie shells. Collection of Joseph Floch. Photograph by Arthur Efland.*

Rites of Passage

During the seclusion stage, children were hidden away for one to five years in a place far from the community. A number of art forms, such as dance, music, sand painting, puppetry and sculpture were used as tools of instruction. Masks, for instance, were worn by instructors in the initiation camps of the Chokwe of Angola. These camps are run by the Mukanda, a male association that oversees the initiation of young boys among the Chokwe, Lunda, Luchazi and Luena peoples. Cikunza, the "father of the Mukanda," is a tall, cone-shaped barkcloth mask used to teach Chokwe initiates a special initiation dance. Among the Dan of Liberia, feminine masks were used to collect and take food to the boys in seclusion. The designs in sand paintings used by the Chokwe presented initiates with information about their history. Clay sculptures were used among the Bemba of Zambia to instruct girls about wifely duties.

In the final stage, rebirth, the initiates were returned to normal life through a series of dances and masquerades. These ceremonies marked the closing of the rites of passage, and informed the whole community that these 13- and 14-year-olds had lost their childhood and were ready for marriage. In some societies, the initiates were given new names to reflect their new identities.

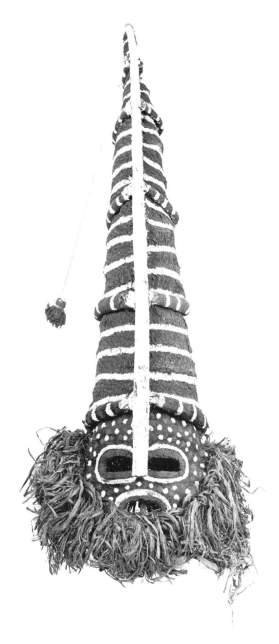

Cikunza Mask
"Cikunza" means grasshopper; grasshoppers symbolize fertility. The long, tapering, cone-shaped headdress represents the horn of an antelope, a symbol of power and virility. The mask is made of barkcloth stretched over a wooden frame. *Chokwe people, Angola. Fiber, paint. Courtesy of Fowler Museum of Cultural History, UCLA. Gift of George O. Frelinghuysen.*

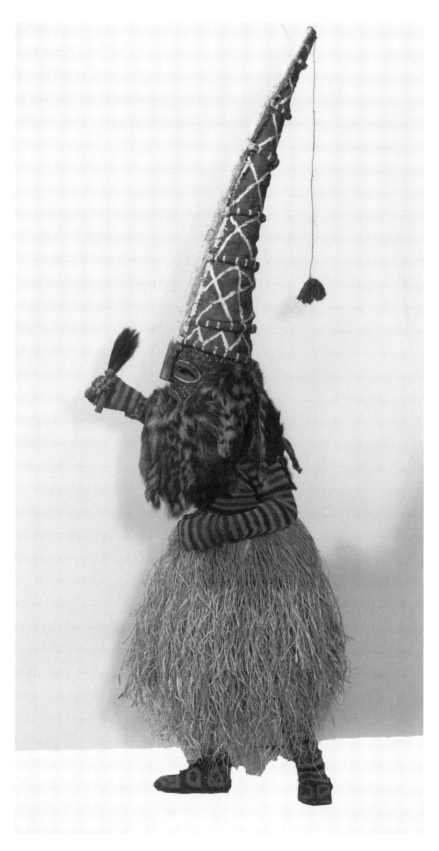

Cikunza Mask with Costume
The Cikunza costume is knitted of black, white and red fiber. It covers the entire body, including the hands and feet, to give the impression of a spirit presence. *Chokwe people, Angola. Courtesy of Museum of Natural History, Washington, DC.*

Boys' Initiations

> *T*he seclusion stage of initiation was the most important. Children were taught the responsibilities of adulthood. The boys' ceremony was usually more elaborate than the girls.

Boys underwent a group initiation, intended to cut all ties between the young man and womenfolk. During this time the boys were taught, by older men, cult secrets, the history of their ancestors and the sacred dances, songs, rights, and duties of adulthood. They also learned about the society and hunting and farming skills. Bamana boys in Mali, for example, performed ceremonies and farmed special ritual fields. The crops from these ritual fields were used to prepare a feast for the coming-out ceremony. Boys were also taught religion and many secrets pertaining to rituals and masquerades not shared with women. A boy who revealed such secrets could be put to death or severely punished.

In most societies, the closing of a boys' initiation camp was marked by much celebration. Costumes, masks and body painting were used to show the change from childhood to adulthood. Body painting was used in coming-out ceremonies to beautify, protect or show a boy's place in society. The whole body or parts of the body would be painted with a fine white clay called red camwood or the powder made from kaolin. For example, Fulani men participated in a "beauty contest" dur-

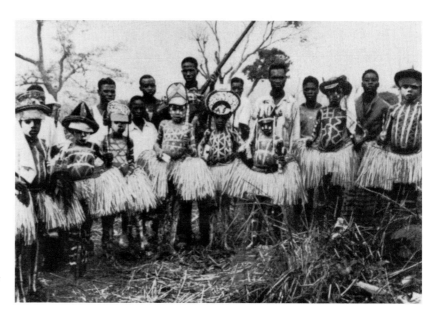

Boys' Initiation, 1960
Strikingly different patterns were painted on each boy before he danced and sang at the coming-out ceremony. Body paint was worn to disguise the boys and protect them from evil forces on the day they returned to the village after their schooling. *Chokwe people, Samuhunga Village, Angola. Courtesy of Marie Louise Bastin.*

ing an initiation rite. They cleaned and oiled their bodies and faces, then painted them with elaborate stripes and triangular patterns. The Chokwe of Angola and Zaire painted special geometric patterns, each having its own name, in red and white on boys' bodies for their coming-out ceremonies. The purpose of the painting was to disguise the boys and protect them against negative forces.

Bamana boy initiates of Mali prepared their own N'domo masks for their coming out. They oiled them for a shiny appearance and adorned them with cowrie shells, leather strips and red seeds. The masks were then rubbed with powder and the red juice of the kola nut. As the initiates returned from the fields, they danced and shook their rattles to regain the strength they lost during farming.

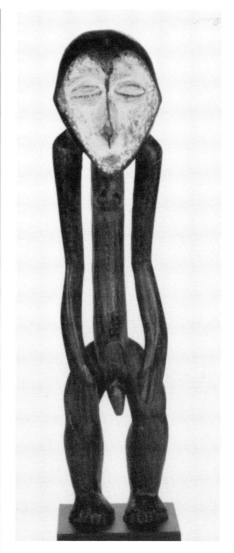

Ofika
This figure was used to teach boys the necessity of secrecy. A series of such figures symbolized people who had been hanged for revealing secrets. The white face and hunched shoulders indicate that the person is dead. *Mbole people, Zaire, 20th century. Wood, paint, 32" (84 cm). Courtesy of Charles Mack.*

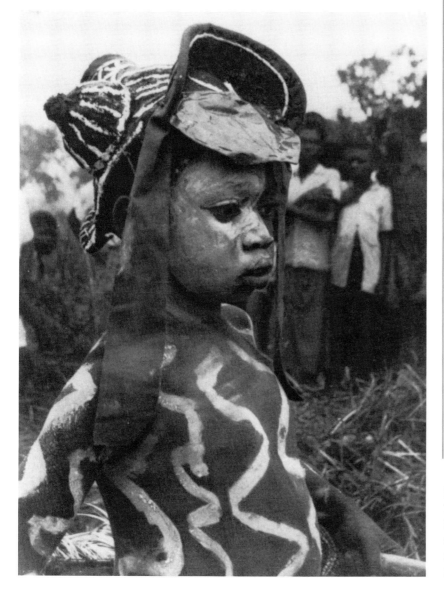

Body Painting
The decorations on this boy were applied by hand in a random manner. The zigzag pattern shown here was quite popular. *Chokwe people, Samuhunga Village, Angola. Courtesy of Marie Louise Bastin.*

Rites of Passage

Girls' Initiations

During their initiation, girls learned about homemaking and having children. They learned to cook, clean, sing and dance, and to make herbal medicines.

By contrast to boys, girls generally underwent their initiations one by one or in small groups. They were separated from daily life and prepared physically and mentally, by older women, for the female adult life of marriage. In some societies (the Bemba of Zambia, for example), women used clay figurines to teach girls between the ages of nine and

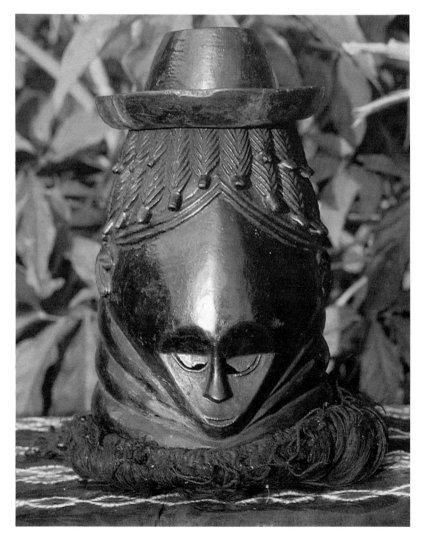

Mende Mask
Features placed in the lower part of the face and the presence of rings of fat are typical of Mende masks. This one is used during the coming-out ceremony of initiation. Notice how the neck rings accentuate the shape of the face. *Gola or Vai people, Sierra Leone. Wood, 8 ½ x 10 ½ x 17 ¼" (21 x 26 x 44 cm). Courtesy of Charles Miller.*

thirteen about marital relationships. This initiation process could last two to five years.

Girls' coming-out ceremonies were usually less elaborate than boys', and masks were not routinely used. Two exceptions were the Gola and Vai women of Sierra Leone and Liberia, where women performed masked dances three times during initiation. These women used a dark helmet mask called Sowei, which represents a female water spirit connected with the Bundu or Sande women's secret society responsible for the girls' initiation. Women hired a carver to carve the mask and dictated the form it should take. When the mask was complete, it was coated with vegetable dye. Constant polishing and the application of palm oil gave it a black, lustrous shine—the color of the spirit of the waters. In societies where masks were not part of a girl's coming-out ceremony, changes in the girls' status were most often marked by hairstyle, the number of beads they wore or the type of dance they did.

In contemporary African societies, some of these practices have changed. In urban areas, many people have rejected traditional ways of life for Western ones. As the educational system has changed, the mother no longer has the sole responsibility of educating the child before puberty. Public schools have taken over much of that education. Some rural children, however, still undergo initiation, and many initiation art objects are still being made and used.

Mask Dancing
The Bundu mask is worn with a costume of raffia, black cloth with sleeves and black stockings. Bundu, identified by the red bandana, is the primordial female ancestor who was the first to teach young girls. *Gola or Vai people, Sierra Leone. Courtesy of Charles Miller.*

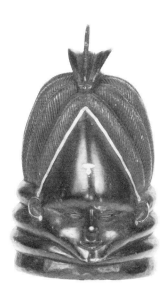

Bundu Mask
The swelling features of this girls' initiation mask reflect the ideal of feminine beauty: lustrous black skin, high forehead and a squat, diamond-shaped face. Bulges, or fat rings, around the neck symbolize health, beauty and well-being. Note the contrast in the textures of the hairstyle and face. *Gola or Vai people. Liberia. Wood, paint, 8 3/16 x 15 15/16" (22 x 40 cm). Courtesy of Charles Mack.*

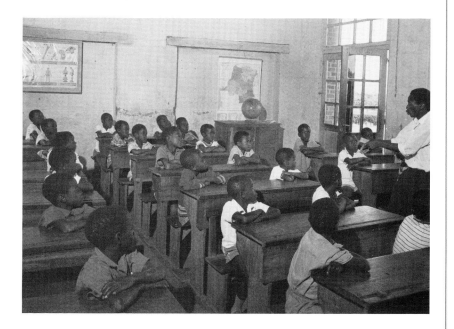

Children in a Catholic Mission School
With the introduction of Western ideas to traditional African society, many children attend public or private schools to receive a Western-style education. *Bunia, Zaire. Courtesy National Museum of African Art. Photograph by Eliot Elisofon, 1970.*

Death & the Afterlife

*T*o most Africans, the movement from death to the afterlife is like returning home. Artworks used in death rituals make the transition to life beyond the grave safer and easier.

The rites of passage of death in most African cultures were usually made up of three stages very much like those of initiation. Various rites, performed during all three stages, were used to send off the dead person peacefully, to cut his or her ties with the living, and to ensure that normal life continued among the survivors.

The first stage was separation, during which the corpse was embalmed, smoked or wrapped for burial. In some communities, the body was washed with water or traditional medicines. In other areas the head was shaved and the nails were cut off. Survivors stopped their normal day-to-day activities for a period of time. Digging the grave, building the coffin, preparing the body, taking it to the cemetary and breaking the dead person's tools were all acts that separated the dead from the living.

The second phase was a period of formal mourning before the funeral. Food was collected and preparations were made for the funeral. Mourning was shown through certain forms of dress and hairstyles. Certain actions such as intimacy were limited or not allowed, especially by the wife or husband of the deceased. Depending on the person's importance in the community, this period of mourning could last as long as a year.

Only the deaths of important people were marked by highly visible works of art. These works appeared during the third phase, at the end of the funeral. Some societies used masks while others used statues. Still others used effigy pots to hold an individual's remains and reliquary figures to guard the remains. These forms may have been used to aid the spirit's movement to the other world by acting as containers for the period of transition, as protectors of the person's remains, as containers to hold food and drink for the afterlife, and as memorial figures.

When a Yoruba woman of Nigeria had twins and both or one of them died, she had small wooden images called *ere ibeji* carved to repre-

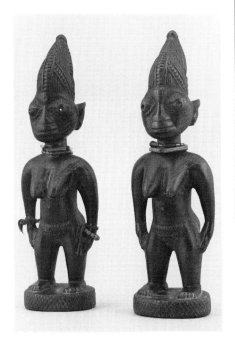

Ere Ibeji
These noble figures have somewhat rounded forms. Often mothers adorned the bodies of ibeji images with cowrie shells, beads and metal bracelets or anklets, or dressed them in little dresses, jackets or hats. *Yoruba people. Nigeria, 20th century. Wood, beads, fiber. Courtesy of the Art Institute of Chicago, gift of Jeffrey and Deborah Hammer.*

sent them. These figures provided a resting place for each spirit, with the hope that the spirit would be reborn into another child by that same mother. In traditional African culture, twins were both honored and feared. Considered to share the same soul, twins were feared because they were thought to have special powers which could bring luck or misfortune to a family. According to tradition, each person on earth had a spirit double in the sky; in the case of twins, the spirit double was believed to have been born on earth. Since there was no way to distinguish the heavenly being from the mortal, both were treated as sacred from birth.

***Ere Ibeji* Statues**
An elderly Yoruba woman sits with the figures thought to contain the spirits of her deceased twins. A mother would periodically wash the figures, paint them with cosmetics and feed them on the day the twins would have been honored had they lived. *Ila-Orangun, Isedo Quarter. Wood. Courtesy of J. Pemberton 3rd.*

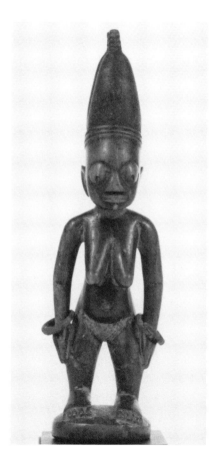

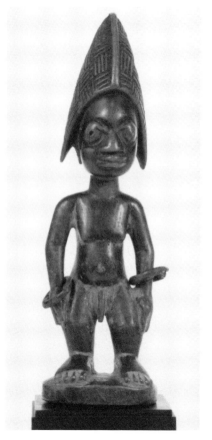

Ere Ibeji
The strong, noble pose of these figures speaks of the power of twins. The bulging eyes suggest the presence of the spirits of the dead. The heads are painted with indigo and the bodies are painted with camwood. Children in the 19th century were painted this way. *Yoruba, Nigeria. Wood. Courtesy of Charles Mack.*

Okuyi Mask
This mask represents the spirits of dead maidens. The mask is worn by a male relative of the deceased person. The white color is a symbol of genderless peace, deities, spirits of the dead and the afterlife. *Punu people, Gabon. Wood, pigment, 7 ¼ x 11 ¾" (18 x 30 cm). Courtesy of Charles Mack.*

The Bakota and the Hongwe of Gabon used reliquary figures to protect the remains of important individuals. The Hongwe, for example, created reliquary guardian figures dedicated to *Bwiiti,* the spirit of the ancestors. Such figures were placed on baskets containing the skulls and bones of great ancestors. It was the job of the Bwiiti to guard the bones from evil forces. Bwiiti figures were also used when the well-being of the village was in danger. At this time, each family took out its Bwiiti and participated in a communal rite. The figures were carefully cleaned in river sand before the ceremonies. The Bakota of Gabon also make reliquary guardian figures called *Mbulu Ngulu,* which served the same purpose as the Bwiiti.

Other people, such as the Akan of Ghana, created terra-cotta clan pots called *abusua kuruwa,* which served as containers for foods and beverages that would be used by the individual in the afterlife. Blood relations of the deceased shaved their heads, cut their fingernails and placed them in another pot, sometimes along with fingernail and hair clippings of the deceased. These pots were left on the grave before the end of the first week after burial.

The Anyi of Ghana and the Côte d'Ivoire made mma figures and heads, which served as portraits of deceased royalty. They were hand-built, probably by women, and painted and dressed the day before the final funeral rites. They were carried in procession through the town to the royal mausoleum, accompanied by much waving and shouting. These figures were placed near the cemetary, but not on the grave itself. Annual libations, offerings and prayers would be given to the ancestors at the beginning of the new year.

Works of art that were used in death rituals were often also used in initiation ceremonies, since they were

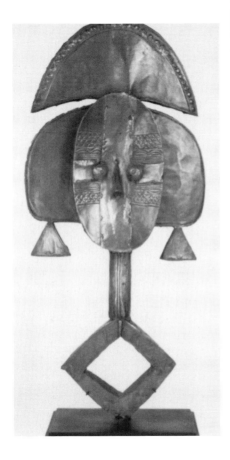

Mbulu Nbulu Reliquary
Beneath the face is a diamond-shaped body that was inserted into a basket or cylindrical box. The front part of this wooden figure is covered with an overlay of brass or copper sheeting. Bakota reliquaries are two-dimensional sculptures: They are meant to be seen from the front. *Bakota, Gabon. Wood, metal, 25 ¾" (65 cm). Courtesy of Charles Mack.*

Bwiiti Reliquary
The cylinder at the top of this figure's head is said to represent a hairstyle worn by elder members of the ancestor cult. The shiny copper covering the figure is a sign of wealth, life and prophecy. *Hongwe, Gabon. Wood, metal, 8 ¾ x 4 ¾ x 23 ⅜" (22 x 12 x 59 cm). Courtesy of the Smithsonian Institution Museum of Natural History.*

both connected with a passage. The Senufo of the Côte d'Ivoire, for instance, used a *Kepelie* mask during important coming-out and funeral rituals. Although it was owned by a man, it represented the concept of feminine beauty, and was considered the "girlfriend" or "wife" of the animal-type helmet masks with horns.

Some objects used for funeral purposes are no longer in use, such as the *mma* figures from the Anyi region. They were not made after about 1914, when most of the peoples of the region were converted by the charming Liberian prophet Harris, who preached his own brand of Christianity. Other artworks, such as some masks, are still being produced because of their entertainment value.

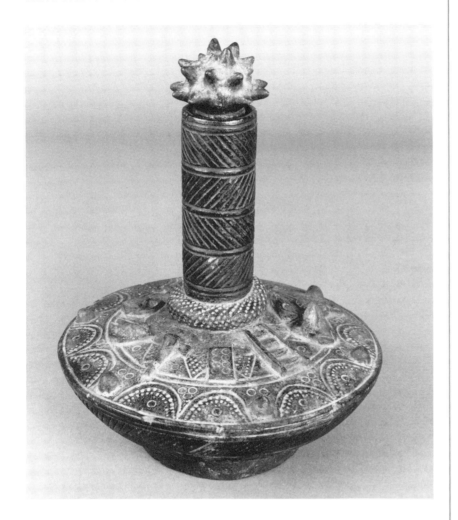

***Abusua Kuruwa* Family Pot**
The imagery on many clan pots refers to the realm of death and the objects necessary for a person's 40 day transition to ancestral status. For example, nearly all the pots show a short "ladder of death" in relief. This refers to the proverb "it is not only one man who climbs the ladder of death," meaning death comes to everyone. *Akan, Ghana. Terra-cotta. Courtesy of National Museum of African Art. Photograph by Ken Heinen.*

***Kepelie* Mask**
This mask, used during initiation and funeral rites, was decorated with an emblem representing the caste of its owner, always a man. Emblems included a comb (for agriculture), a bird (for blacksmiths) and a bundle of palm nuts (for wood carvers). The mask was worn with a cloak made of long fibers, and a knotted robe decorated with black lozenge shapes. *Senufo, Côte d'Ivoire. Wood. Collection of Joseph Floch. Photograph by Arthur Efland.*

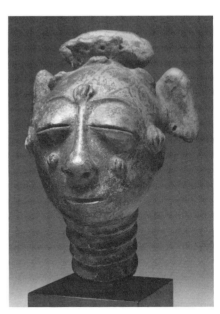

***Mma* or Funerary Head**
Notice the hairstyle of this piece, which consists of several wedge shapes that flare outward from the head. In the past, ceramic figures and heads were reserved for royalty, but later they were used for all adults. *Anyi, Côte d'Ivoire. Fired clay, pigment. 5 ¾ x 6 x 7 ½" (14 x 15 x 19 cm). Courtesy of University of Iowa Museum of Art, the Stanley Collection.*

COURT ART

*A*frican rulers used art to show their wealth and power. Thrones and jewelry, statues and musical instruments helped impress and control a ruler's people.

Ivory Tusk
This carved tusk is separated into four sections. The images portray individuals in ceremonial costume holding emblems of office. It would have been inserted into the top of a commemorative head of an Oba and placed in a shrine. The tusk then symbolized the path to the ancestral world. *Benin, Nigeria. Ivory, 22 ¼" (58 cm). Courtesy of Charles Mack.*

The type of court art a culture produced depended to some extent on whether the government was centralized or decentralized. In the centralized states, the king controlled society. Believed to have received his power by divine right from the ancestors, the king was responsible for ensuring the fertility of the land, a stable economy and the well-being of the community. By emphasizing his mythical ancestry, a king and his dynasty were able to extend their religious and political power to form a state or kingdom. The arts of centralized states usually reflected the prestige and the religious and economic powers of the ruler.

By contrast the rule of decentralized African governments was based on the kinship system and the ancestor cult. Here the highest power belonged to elders, heads of extended families and high-ranking members of men's associations. Decentralized villages functioned independently and were self-supporting. Many times a legendary culture hero was associated with the society. The works of art from decentralized states usually reflected the desires of its members to achieve the qualities of that culture hero.

Whatever the size of the realm, African rulers shared many common traits. Usually they owned the land, receiving grain, farm animals, cloth or other objects for its use from the villagers. Because African rulers were usually both religious and nonreligious leaders, they were responsible for both spiritual security and civil order. The art objects they used symbolized their power, wealth and sacred status. Many great African kingdoms produced fine examples of court art between the fourteenth and nineteenth centuries. But at the beginning of the twentieth century, with the spread of Islam, Christianity and colonialism, traditional court procedures were ended in many empires. Some kingdoms, however, such as the Asanti Empire of Ghana, the Kuba of Zaire, and the Yoruba Kingdom still have figureheads similar to Queen Elizabeth; while they have no political power they may have spiritual power or court responsibilities.

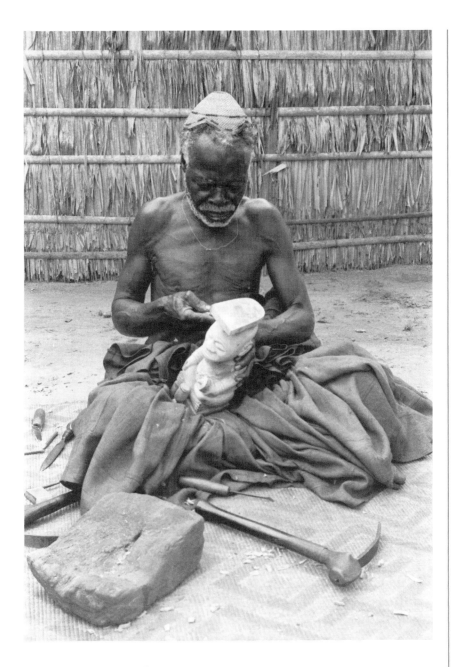

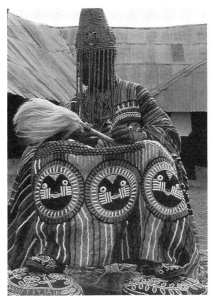

The Deji (King) of Akure in Ceremonial Dress
Although they conducted ceremonies for their people, generally African leaders were hidden from public view by either a curtain or veil. This Yoruba king shields his face with a beaded crown. The beads signify his high rank; the crown of beads indicates that his head is holy. *Yoruba people, Nigeria. Courtesy of National Museum of African Art. Photograph by Eliot Elisofon.*

Sculptor Carving a Portrait Statue
Royal statues, called Ndop, portray past or reigning kings. The first known Ndop is from the 18th century. They are used to house the spirit of the king. This sculptor is carving an Ndop representing Bom Bosh, who reigned in 1650. *Kuba people, Musenge, Zaire. Courtesy of National Museum of African Art. Photograph by Eliot Elisofon, 1970.*

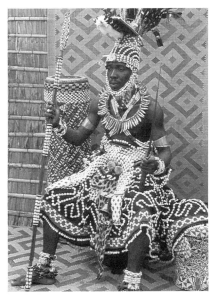

A Kuba King
This modern king, Kot a Mbweeky III, wears a headdress, a belt embroidered with cowrie shells and a royal knife. These and other pieces of chiefly finery were intended to glorify the king and impress his subjects. *Kuba people, Zaire. Courtesy of National Museum of African Art. Photograph by Eliot Elisofon, 1971.*

Thrones

Often, only a king and his royal court were allowed to use raised seats, or thrones. Everyone else sat on the ground. Some thrones were carved with symbols of the king's power.

A royal African throne could look like a stool or a chair. Most stool-type thrones were carved from one piece of wood, and had a central supporting pedestal running between a base and a round or rectangular seat. The pedestal was usually either surrounded by carved human or animal figures or was itself ornately carved in the form of a human or animal figure.

In some cultures, different sizes of stools were used for different events. The Bamun people, for example, from the eastern grasslands of Cameroon, made fancy beaded stools in two sizes. Large stools were reserved for the king at ceremonial occasions; small stools were used in more personal settings, such as when the king was meeting with his court.

The use of chair-type thrones is more recent. They were probably influenced by Western designs, since many of them have European-style backs made of thin pieces of wood, called splats. Generally the splats had little use since their diagonal position made leaning back difficult.

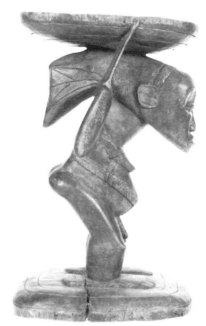
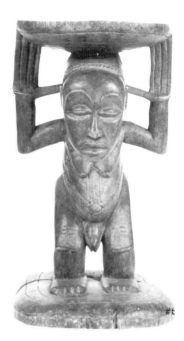

Luba Stool
The central pedestal of this stool is carved in a half-male, half-female figure. It supports a round seat. Notice how the crossing and repetition of angular forms results in a very balanced composition. *Luba people, Zaire. Wood, 18" (46 cm). Courtesy of Charles Mack.*

Instead, a king usually perched on the front edge of the chair. The design of the chairs built for the Chokwe chief of Angola was based on sample chairs that had been imported from Europe. The chairs were made from many pieces of wood joined together. They usually had splat backs, rungs, leather seats and plenty of imported brass nailheads.

The splat and rungs were usually covered with images of people portrayed in everyday activities and different masks used during the Mukanda initiation rites. These images showed different scenes of initiates, Europeans in helmets, dancers in grass skirts, soldiers with rifles or abstract animals.

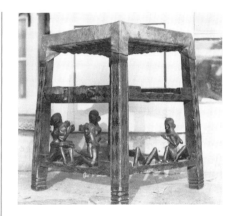

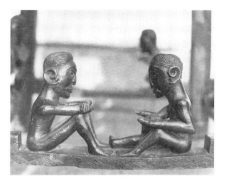

Ndembu-Lunda Stool
The rungs of this stool are carved with figures performing non religious or sacred acts. This stool belonged to a leader of lower rank than a chief. *Ndembu-Lunda people, Mwinlunga region, Zambia. Wood, antelope hide. Courtesy of Jacqueline Chanda.*

Throne
This throne was made from several pieces of wood. The stretchers and splats are decorated with small, rhythmically repeating sculptures. *Chokwe people, Angola. Wood, 39" (99 cm). Courtesy the Metropolitan Museum of Art, the Michael C. Rockefeller Memorial Collection, 1970.*

Portraits

African portraits were not made to show what a person really looked like. Instead, they were used to show the person's place in the family or community. Hairstyles or special decorations often told which group a person belonged to.

African portraits were most often idealized images—it was considered disrespectful to show wrinkles, blemishes or any emotional facial expressions. Although the characteristics of portraits were determined by social rules or standards, the portraits pictured people who really existed. They were used to commemorate important people who had

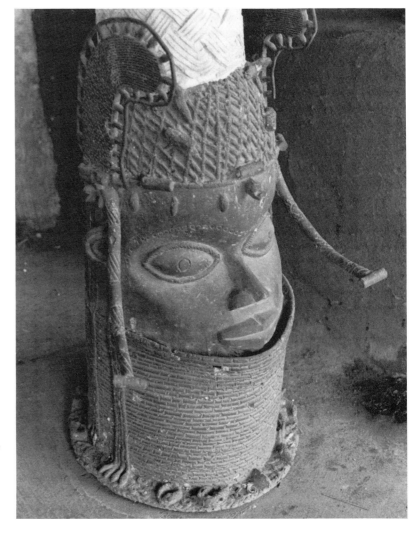

Royal Commemorative Head of an Oba
This hollow portrait head shows the elaborate cap and collar of coral that was worn by the Oba on important occasions. The walls of the cast are only ⅛ inch thick. Note the large carved ivory tusk inserted into the hole at the top of the head. *Benin, Nigeria, 18th century. Cast copper alloy, iron, inlay, 12 ¼" (31 cm). Courtesy of National Museum of African Art. Photograph by Eliot Elisofon, 1970.*

given generously to society, such as heads of households, kings and chiefs, strong females and priests.

Court art portraits took many forms. They included heads, statues, masks, or pots made from bronze, wood or terra-cotta. Some of the heads held a large carved ivory tusk, which was thought to symbolize the path to the world of the ancestors. All ivory was reserved for the king's use, although chiefs were allowed to have carved tusks on their shrines.

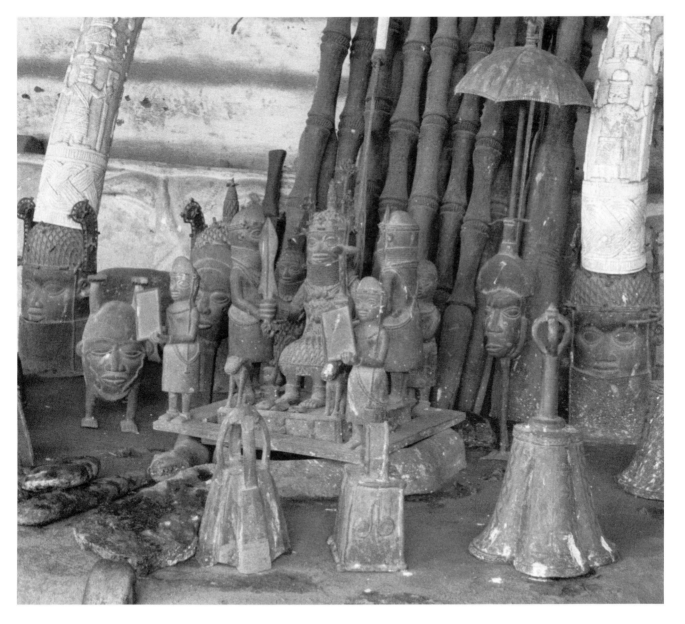

Ancestor Shrine
This ancestor shrine belongs to the Oba and contains bronze heads with ivory tusks. It is dedicated to Eweka II (reigned 1913–1914). *Benin, Nigeria. Courtesy of National Museum of African Art. Photograph by Eliot Elisofon, 1970.*

Royal portrait statues, called *Ndop*, were carved by the Kuba of Zaire to serve as resting places for the spirits of their kings. These statues were carved during the king's reign or after his death, and kept hidden. A king nearing death would shut himself up with his Ndop, so that it would take up his last breath. In this way the statue became the guardian of the sacred power which was taken over by the next king.

The Bangwa of the Cameroon had a portrait carved for each king when he was crowned. A portrait would also be carved of the mother of the king's eldest son, who was often shown in his mother's arms. These statues were set outside the palace under the eaves of the roof, where they would be exposed to the sun, rain and termites. They are believed to have been on permanent display as a sign of the king's fertility. Each king kept the portraits of previous kings, as memorials to the dead.

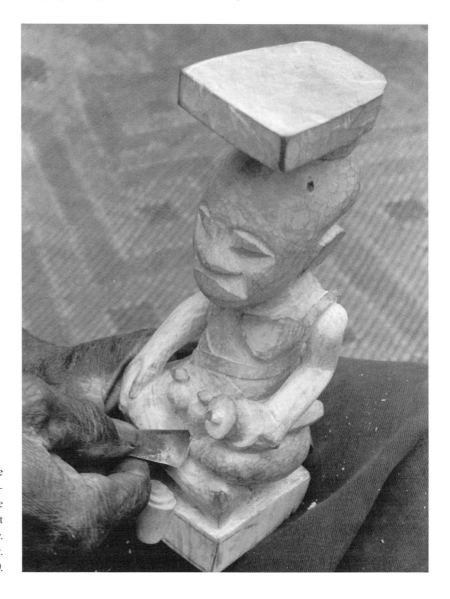

Sculptor Carving a Royal Portrait Statue
Called a Ndop, a royal portrait statue was considered to be a king's double. It reflected the ruler's state of well-being, and housed his spirit when he died. *Kuba people, Musenge, Zaire. Courtesy of National Museum of African Art. Photograph by Eliot Elisofon, 1970.*

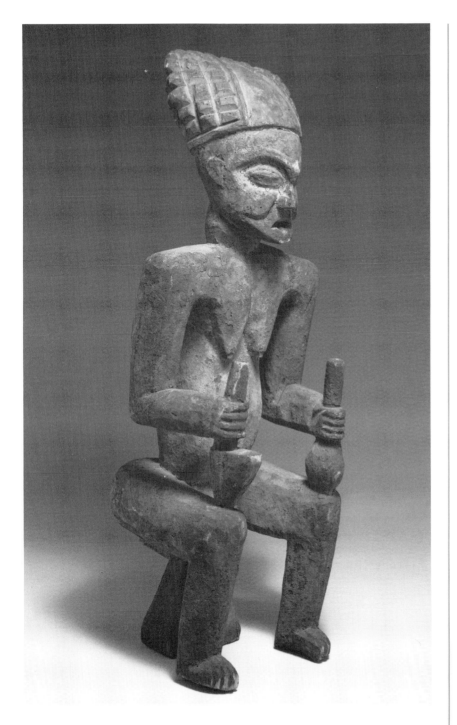

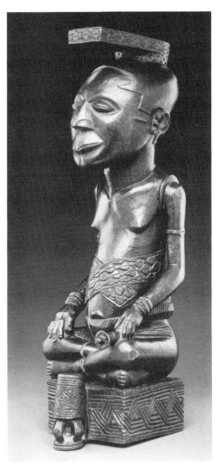

Ndop Statue
This portrait figure wears a royal headdress and belt decorated with cowrie shells. Note the ibol (the object carved in full relief and attached to the front of each base), which symbolizes the reign of a specific king. *Kuba people, Zaire. Wood, 7 ⅜ x 8 ⅞ x 24 ⅛" (19 x 22 x 61 cm). Courtesy of the Metropolitan Museum of Art, gift of Lawrence Gussman, 1979.*

Royal Portrait
Seated on a royal stool, the mother of the eldest son of the king holds two leadership symbols—a calabash in her left hand and a pipe in her right. *Bangwa people, Cameroon, 19th–20th century. Wood, 8 ½ x 7 x 22 ½" (21 x 18 x 57 cm). Courtesy of the Stanley Collection, University of Iowa Museum of Art.*

Royal Adornment

*M*any objects that were used by the king, such as the fly whisk, or the drums, were also used by common people. Those that belonged to the king were always more richly crafted.

African royalty surrounded themselves with luxurious objects to show their position in society and their power. These objects were often either made or decorated with precious materials such as beads, ivory, special woods, gold, brass, bronze and silver. Sometimes the decorations did nothing more than add beauty and elegance to the item; sometimes the designs communicated messages relating to the office of the chief and his military, financial and spiritual strength.

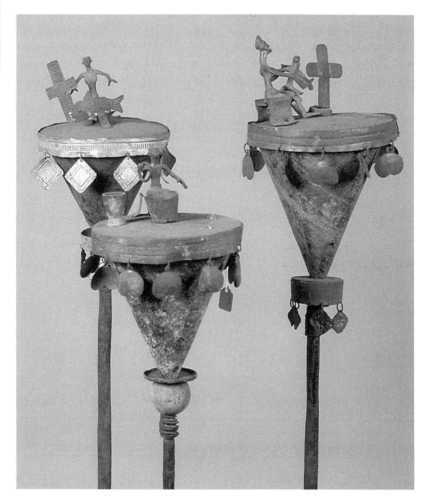

Fon Staff
The fon staffs were displayed in royal compounds to commemorate deceased rulers. The figures topping the staffs are believed to be images relating to the rulers. *Fon people, Republic of Benin. Bronze or brass, iron. Collection of Richard Hunt. Photograph courtesy of Vesta Daniel.*

Staffs of office, ceremonial knives and axes, and state swords—all of which are considered royal objects—belonged to the kings alone. These objects served to separate the king and his family from society. Staffs of office, which were often topped by various figures and motifs, extended the body of the chief holding them, making the chief appear more powerful. Knives and axes were symbols of noble authority, and were generally carried by a king or chief only at important ceremonial occasions. Among the Asante of Ghana, state swords symbolized the wisdom and power of the chief.

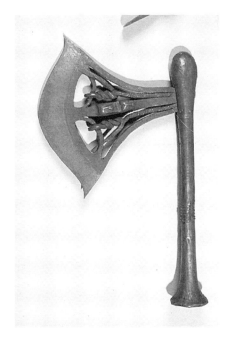

Ceremonial Ax
The handle of this ax is covered with copper sheeting. The decoration between the handle and blade consists of an ornamental face between rods of twisted iron. The face is a representation of a ruler. *Songye people, Zaire. Iron, wood, copper. Collection of Richard Hunt. Photograph courtesy of Vesta Daniel.*

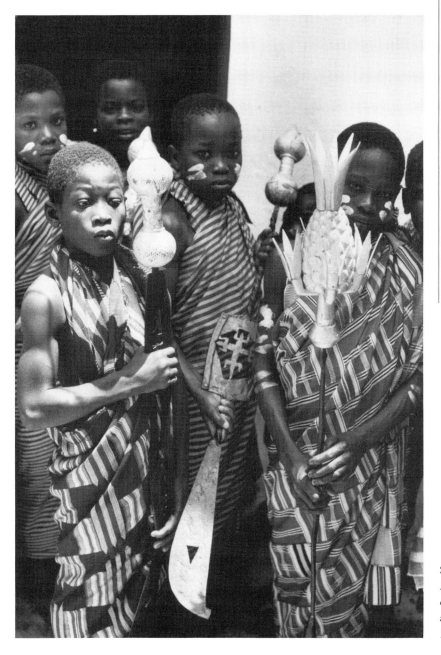

State Swords
At a festival, Fante boys of the royal family are carrying state swords. The hilts of these swords are made of golf leaf over wood. *Fante people, Salt Pond, Ghana, 1975. Courtesy of Doran H. Ross.*

Unlike the royal objects, objects of personal prestige could be owned by whoever could afford the honor. Pipes, for example, were a common status symbol. Smoking, which reached Africa in the sixteenth century, was used both socially and ceremonially, to blow smoke over people or objects during rituals. Most pipes were highly decorated with drawings of pythons, spiders, leopards, bats, lizards, crocodiles and frogs. Some were carved with images telling myths or folktales. The cosmetic boxes made by the Kuba also spoke of the owner's high rank and good taste. These boxes were used to hold perfumy red powder made from camwood, which was used to decorate the hair and body.

Today most African countries are not ruled by kings but by elected presidents, and you are as likely to see a Mercedes Benz automobile symbolizing a person's wealth as you are to see a staff or sword. Still, many rulers, especially in the more rural areas, still depend on traditional objects to symbolize their power and prestige.

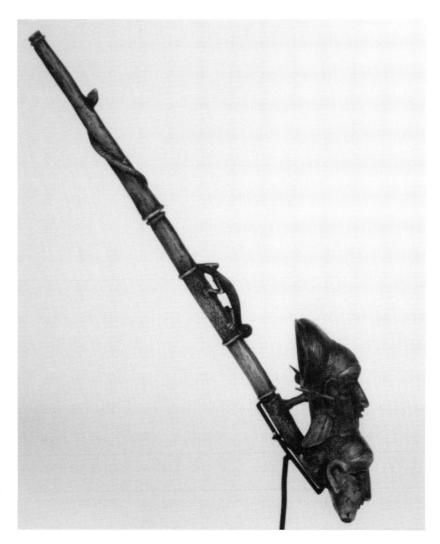

Pipe
The bowl of this pipe is adorned with a chameleon and a snake. The extensions on the side of the top head appear to be birds. *Bagam people, Cameroon. Terra-cotta, wood, iron, 20¾" (53 cm). Courtesy of Charles Mack.*

Cosmetic Boxes
These boxes are decorated with geometric patterns that are similar to the patterns found on musese, or velvet, cloth. They are rubbed with the camwood powder and oil to give them a rustic patina. *Kuba people, Kasai and Congo River Basin, Zaire. Wood. Courtesy of Charles Mack.*

Musical Instruments

***M**usical instruments had great value in African society. They were usually owned by the rich. Priests and rulers used musical instruments to heal and to overcome evil.*

Musicians ranked higher in some parts of Africa than in others, and the methods of learning and employment were varied. For example, any of the Akan people of Ghana who had talent, ability and interest learned simply from whatever music surrounded them. They formed organizations of men, women, or both, each of which specialized in one type of instrument, such as the hand piano or hand drum. By comparison, the Hausa musicians of Nigeria, who were of lower rank than the Akan musicians, were taught their trade. Their jobs as musicians were inherited from their fathers' lines. By the time they were seven to ten years old they started learning from family members or by apprenticeship. As professionals they formed musical groups, each under a leader.

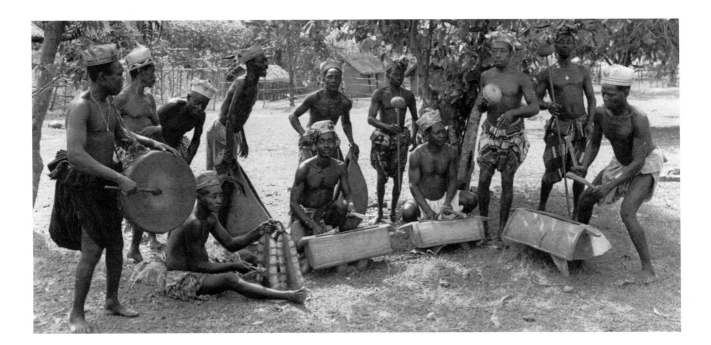

Musicians Accompanying a Circle Dance
These musicians use split gongs and drums to accompany a circle dance. Each instrument is usually made from a tree trunk, which has been hollowed out with a tool inserted through a slit made in the top surface. The thickness of the wood on each side of the slit is varied to produce two tones. *Mangbetu people, Medji, Zaire. Courtesy of National Museum of African Art. Photograph by Eliot Elisofon, 1970.*

In general, a professional musician made a living of his or her music, while the musician of the court played an instrument as one part of his or her job. The court musician would play a horn, flute or a certain combination of drums, all of which could only be played in the court. When accompanying dances and songs, musicians did not use sheet music, but played spontaneous rhythms. The making of a musical instrument was usually a project shared by a craftsman and a sculptor. The craftsman began the work, and the sculptor added the finishing touches.

Musical instruments—and the musicians who played them—are often the subject matter of other African art forms. For example, in the Kingdom of Benin, brass figures of flutists were displayed on altars along with those of the deceased Oba, or king. In Zaire, among the Lumbo, drum hooks were fashioned to represent drummers in motion. These examples demonstrate the importance of music and the musician in African societies.

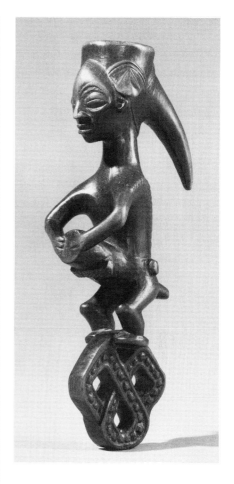

Drum Hook Player
This wood figure is obviously intent on his drumming. Note the flexed knees belt elbows, which generate a feeling of movement. *Lumbo people, Zaire, 19th–20th century. Wood, 6" (15 cm). Courtesy of The Metropolitan Museum of Art, the Michael C. Rockefeller Memorial Collection, 1972.*

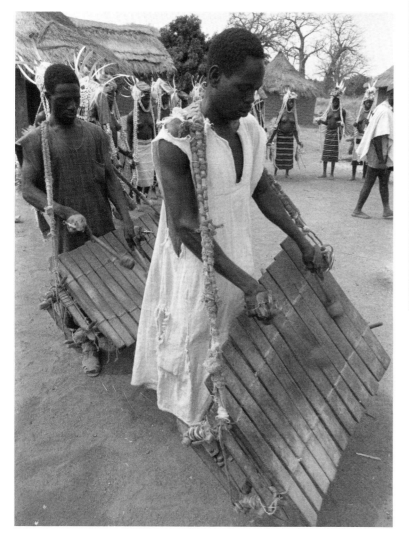

Balaphon Player
A balaphon is made of bamboo keys, which are attached to gourds. It is an idiophone that sounds similar to a xylophone. *Senufo people, Bouniali, Côte d'Ivoire. Courtesy of National Museum of African Art. Photograph by Eliot Elisofon, 1971.*

Although many people think that traditional Africans played only drum music, in fact many different types of musical instruments were used in masquerades and dances. Depending on how the sounds are produced, these instruments fall into several different categories. They include the idiophones, aerophones, membranophones and chordophones. Idiophones are instruments like gongs, in which sound is made in the body of the instrument upon striking; aerophones are instruments like flutes and horns, through which a player blows air; and membranophones are drums. Chordophones are instruments that have strings, like harps and guitars.

Of the idiophones, the most highly decorated instruments were usually the slit gongs, the sanza (thumb piano) and the metal bells. Slit gongs, which have a single slit carved in the middle, were sounded in times of need or crises, and were typically used to call men to war. Huge slit gongs were made for the Bamum kings of the Cameroon; when a king died, his instrument was left in the market square to deteriorate from the elements. It is believed that the decay of the drum symbolized the death of the king.

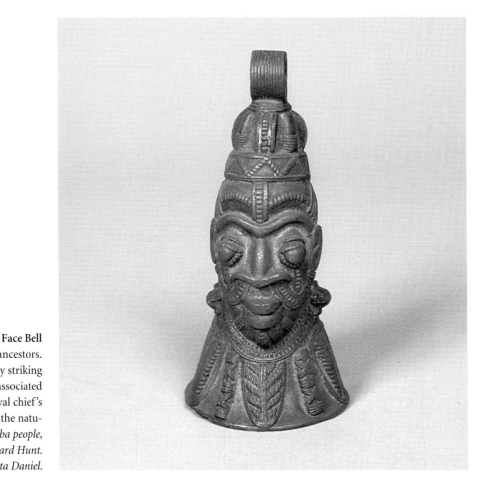

Face Bell
Bells in southern Nigeria represented ancestors. A person could contact ancestors by striking the bell. This head-shaped bell is associated with leadership and is worn on a royal chief's left hip during public festivals. Notice the naturalistic features and large eyes. *Yoruba people, Nigeria. Bronze. Collection of Richard Hunt. Photograph courtesy of Vesta Daniel.*

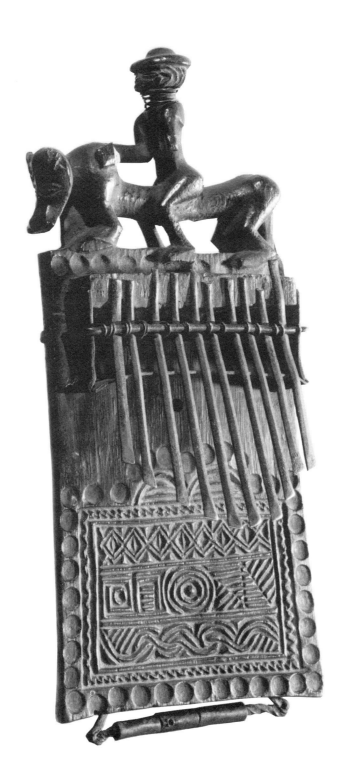

Thumb piano
The thumb piano, or sanza, has a series of tuned thin, flexible keys made of bamboo, wood or iron. They are arranged on a flat wooden soundboard and are struck or plucked with the thumb. Thumb pianos are often decorated with incised geometric patterns or facial images. *Chokwe people, Angola/Zaire, 1915. Wood, iron, 7 7/8" (19 cm). Courtesy of Cleveland Museum of Art.*

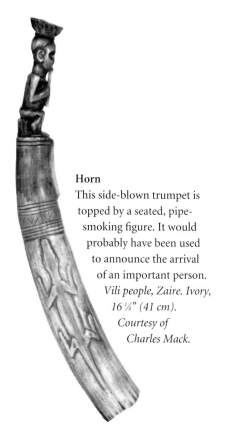

Horn
This side-blown trumpet is topped by a seated, pipe-smoking figure. It would probably have been used to announce the arrival of an important person. *Vili people, Zaire. Ivory, 16 ¼" (41 cm). Courtesy of Charles Mack.*

Of the aerophones, the ivory horns, flutes and whistles were usually the most highly decorated, because they were associated with the court. Horns were most frequently played to announce the presence of a chief of state, and were part of the royal orchestra. They were also used in hunting and in battle, during celebrations or emergencies. Flutes were made out of wood and were commonly used among the Nuna of Burkina Faso at initiation or funerary rites. They were also used to announce the winner of a cultivation competition, or as a signal during hunting and times of conflict. Whistles, which were made of wood or antelope horns, were traditionally used in hunting and healing, and in funeral and initiation activities. Today European-style whistles are liberally used in dance performances.

African cultures are most noted for their drums, or membranophones, which were used for many different purposes. Some are reserved for courtly use, while others are for ritual, military or nonreligious performances. There are several different categories of drums. One category consists of hourglass-shaped drums that have a drumhead at each end. Another category consists of friction drums. The sound is made by rubbing a rod that passes through the inside of the drum. The drums that are most frequently decorated are those with a single drumhead, like the kettledrum or cylinder drum. The decorations could be

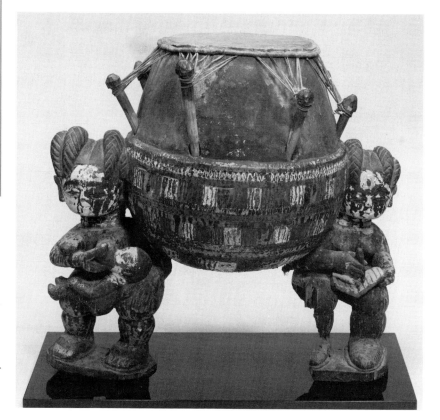

Bowl Drum (Kettle Drum)
This drum is elevated by two figures, one of a mother nursing her child and the other of someone writing in a book. The membrane of the drum, made of leather or cow hide, is attached with seven pegs. *Asante people, Ghana. Wood, pigment, hide, 21" (53 cm). Courtesy of The Metropolitan Museum of Art, gift of Raymond E. Britt, Sr., 1977.*

engraved or added to the drum in geometric, human or animal designs. Royal drums among the Kuba of Zaire, call pelambish, are examples of royal drums. They symbolize the presence of the king and are played only at royal dances and on the day of the new moon. In the earliest examples of royal drums, copper and beads were sparsely used for decoration, but by the end of the nineteenth century, the entire drum surface was covered by these materials.

In traditional African society, the harpist was a high-ranking musician, who usually sang as well as played. Unlike other musicians, the harpist was responsible for learning the history and genealogy of the ruling class, and would sing the praises of the king during special occasions. Most frequently the harpist performed as a soloist instead of an ensemble player. Because of its special importance, the harp, or chordophone, was most frequently decorated with symbolic human elements. These were considered an extension of the performer's soul and body, and often served as a handle for the instrument.

Whistle
This whistle represents a figure holding a snake. Note how the snake, coiled around the legs of the figure, leads your eye to the figure's turned head. *Kongo people, Zaire. Wood, antelope horn, 9¼" (25 cm). Courtesy of Charles Mack.*

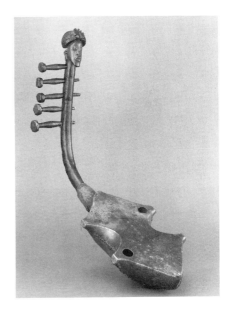

Harp
This instrument is shown without its strings, which would normally extend from the handle of the harp to the sound board. Note how the neck of the instrument ends in a sculpted head. *Zande people, Zaire. Wood, animal hide, metal, 14" (35 cm). Courtesy of National Museum of African Art. Photograph by Jeffrey Ploskonka.*

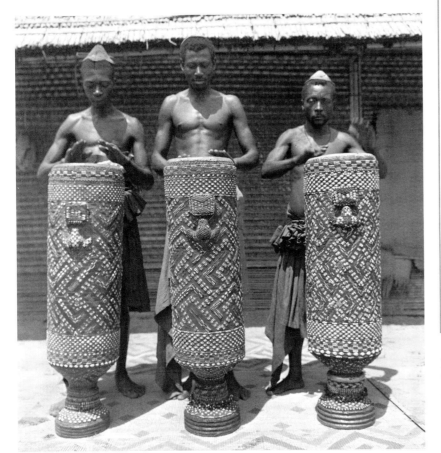

Pelambish
The angular patterns on these royal drums are created by cowrie shells, beads and copper studs. *Kuba people, Mushenge, Zaire. Courtesy of National Museum of African Art. Photograph by Eliot Elisofon.*

Chapter 6

SPECIAL PLACES

Many African societies had a palace the size of a small town. One of the many special places, the palace was heavily decorated with carvings, sculptures and paintings.

Elaborate palaces have existed in sub-Saharan Africa as far back as the fourteenth and fifteenth centuries. Because of their size and use, they were most naturally a part of large urban settlements having a sound centralized government and strong commercial trade. African palaces were often so large that they could be thought of as a city inside of a city, separated by a wall. Many separate buildings, such as courthouses, storehouses, stables, kitchens, and homes for wives and retainers, were gathered within the compound walls. The palace of the kingdom of Buganda in Uganda consisted of 400 buildings; in Hausaland, some palaces covered over thirty-three acres.

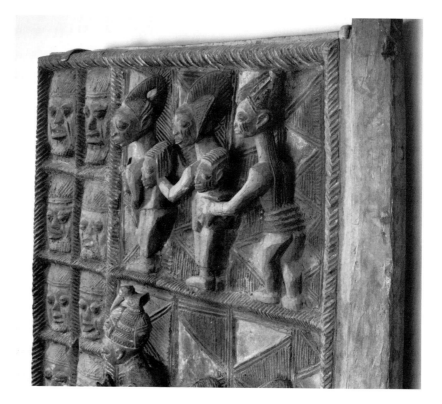

Door by Olowe of Ise (detail of image at far right)
Notice the fine interplay of textured and non-textured areas. The upper parts of the figures are separated from the background, creating an illusion of depth similar to that of the pediment on the Parthenon. *Courtesy of the National Museum of African Art. Photograph by Jeffrey Ploskonka.*

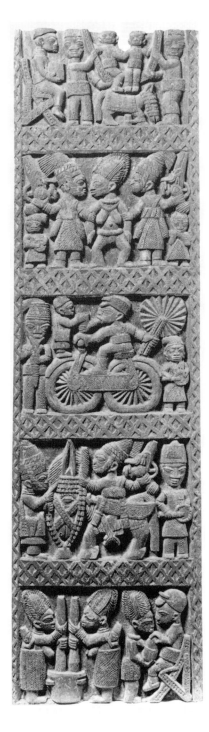

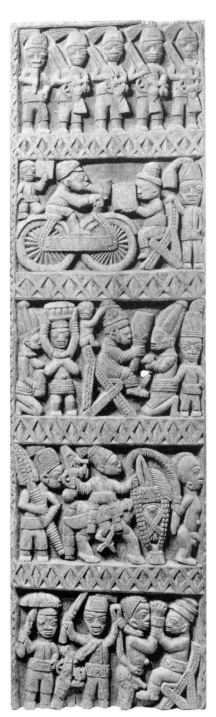

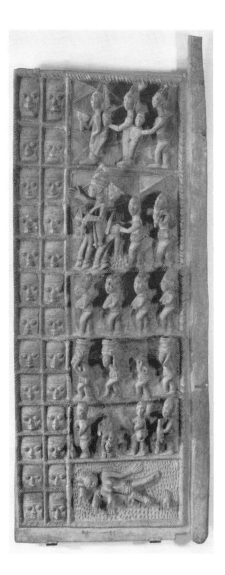

Door by Olowe of Ise
Note how the strong relief carving creates a shadow that gives this door an illusion of depth. The thirteen pairs of faces may refer to the sixteen sons of Oduduwa, the mythical first king and founder of the Yoruba people. Olowe, the carver, who lived from 1875 to 1938, was widely regarded for his architectural sculptures, which included doors and house posts. *Yoruba people, Ekiti group Ise, Nigeria. Wood. Courtesy of National Museum of African Art, Gift of Dr. and Mrs. Robert Kuhn. Photograph by Jeffrey Ploskonka.*

Doors by Areogun of Osi-Ilorin
The figures in these relief-carved doors are crowded into horizontal sections that blend old and new themes from life in Ekiti, Nigeria. A master door carver, Areogun lived from 1880 to 1956. *Nigeria, 20th century. Wood, pigment, 71 ½" (181 cm). Courtesy of University of California Museum of Cultural History.*

The construction of a palace took anywhere from one week to a few years to complete. Although they were made from the same materials as common buildings (clay bricks or lashed palms for walls, grass thatch for the roof), palaces and other special buildings were usually both more sturdily and more finely made. Walls would contain more rows of brick, and thus be taller—up to thirty feet tall in some cases. Sometimes the clay for the bricks was mixed with palm oil rather than water, to give it extra strength and a shinier surface. Or a lime wash was

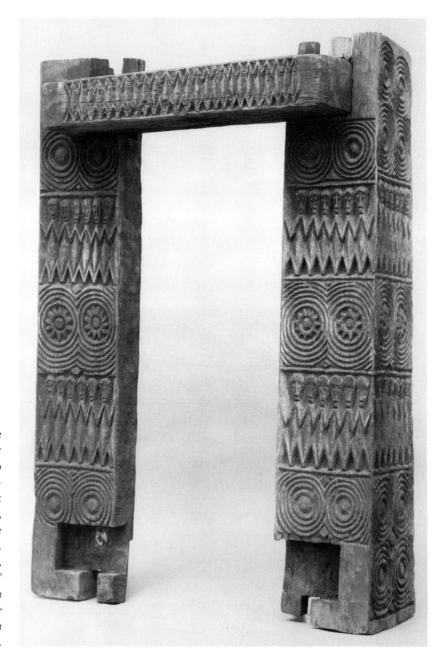

Door Frame
Palaces were often adorned with carved door frames and posts. This frame consists of two heavy posts and a narrower lintel, or crossbeam. The frame is carved with geometric figures and patterns that may refer to legends, myths or the history of the chief. Notice the repetition of forms on the lintel and posts.
Wum, Cameroon, Western Grasslands, 19th–20th century. Wood, 32 x 55" (81 x 139 cm). Courtesy of The Metropolitan Museum of Art, the Michael C. Rockefeller Memorial Collection, Gift of Mark W. Neitlich in memory of David A. Neitlich, 1924.

used instead of plaster to whitewash the walls, because it produced a hard glossy surface.

Whatever their type, special buildings were always highly decorated. The major purpose of all decoration was to display the wealth and power of the people living in the building. Decorations were typically positioned on entrances, eaves, friezes, and inner and outer walls. Doors received special attention, and the palace entryway often contained swinging double wooden doors that were elaborately carved. Verandah posts were also painstakingly adorned. Sometimes the designs were carved directly into the posts, but sometimes the posts themselves were created as sculptural forms.

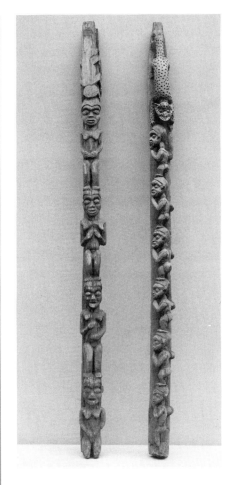

Carved House Post
House posts were often carved with stacked human figures or geometric patterns that told of famous people, hunts or wars. Many times the house posts look like Native American totem poles. *Babanki Cameroon, Western Grasslands. Wood, 96 ½" (245 cm). Courtesy of The Metropolitan Museum of Art, Fletcher Fund, 1972.*

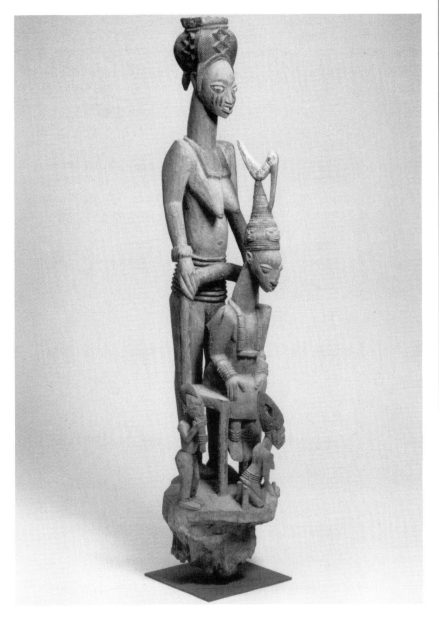

Veranda Post of Enthroned King and Senior Wife
This post, carved by Olowe of Ise, was the central column of a veranda in a palace courtyard. It shows a seated Yoruba king and his senior wife with small attendant figures. Note the use of hierarchy in the proportions: The woman, the larger figure, carries more spiritual power. *Nigeria, Ekiti Areas, 1914. Wood, pigment, 13 ¼ x 61" (34 x 154 cm). Courtesy of Chicago Institute of Art. Photograph by Robert Hashimoto.*

Special Places

In the Benin kingdom, bronze plaques were also used to decorate palaces. These were nailed to the pillars of the palace courtyards. The plaques related the main events in the history of the Benin kingdom, the ruler and his court. Images of animals, warriors, noblemen, hunters, or Portuguese soldiers were commonly used; the backgrounds of the plaques were generally decorated with an all-over surface pattern of vegetation.

The use of bronze plaques covers a period of about 400 years, going as far back as the seventeenth century. By the eighteenth century, plaques were no longer used to decorate palaces. It is believed they were removed from the palace posts and walls following a battle around

Village in North Bulawayo, Zimbabwe
Villages were organized around extended families, or clan members. Unlike city structures, the houses in this village are round, and have mud or bamboo walls. The thatched roofs contrast with the flat and pitted roofs of the contemporary city. *Courtesy of National Museum of African Art. Photograph by Eliot Elisofon.*

1700. They were stored, along with many other old works of art, in the storehouse of the palace. They were referred to whenever there was a dispute about courtly etiquette, because they illustrate ranking order and levels of royal dress. They are used to this day to determine appropriate dress for special presentations.

Today palaces in Africa resemble European structures of the same function. Built from of cement or concrete instead of traditional materials, they are self-contained with many rooms. Consequently, towns have taken on a Western look. Certain design elements remain, however. These are incorporated into the more modern plans in the form of doors and house posts.

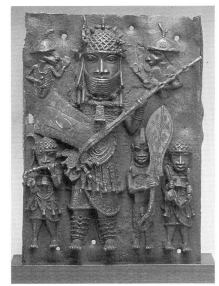

Plaque
This plaque represents a king dressed in warrior's attire. In the upper area, he is flanked by two Portuguese soldiers. A musician and two court officials are pictured on the lower part of the plaque. *Benin Kingdom, Nigeria, 16th–17th century. Cast copper alloy, 15″ (38 cm). Courtesy of National Museum of African Art. Photograph by Eliot Elisofon.*

Cityscape of Liberia
Modern cities in Africa take on a very Western flavor. This could be a photo of any place in California or Florida. *Courtesy of National Museum of African Art, 1960–66. Photograph by Tom Weir.*

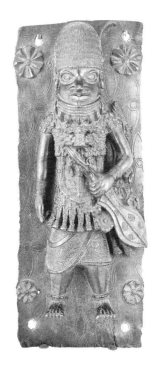

Plaque: Man with Eben
The king is shown with his eben, or sword, which represents a link between the king and his ancestors. The background is decorated with rosettes that represent the sun and what appear to be flower petals. *Benin Kingdom, Nigeria, mid-16th–17th century. Copper alloy, 17″ (43 cm). Courtesy of National Museum of African Art. Photograph by Eliot Elisofon.*

Sacred Buildings

*A*frican communities that didn't have palaces usually still had one or more special buildings. These clubhouses, shrines and temples were adorned with a variety of artworks.

Clubhouses were places where important meetings of secret societies took place. These structures were frequently beautified with wall decorations made of engraved patterns or molded or painted geometric designs. The painting was usually done by women. In some areas, home improvement and wall painting was done in the dry season after the crops had been gathered, dried and stored. In other areas, improvements were performed before the strong rains from late February to late April. Paints and pigments were applied to freshly plastered surfaces, so the colors would be absorbed by the plaster. Among the Igbo of Nigeria, women decorated the outside of shrines the same way. Among the Gurensi of Ghana, the houses are painted by women, but the shrines are painted by men. In this society, the men are responsible for taking care of the shrines.

African places of worship range in scale from ultra-simple traditional ancestor shrines to spacious temples and mosques. Because Africans traditionally worshipped outdoors, ancestor shrines, which

Gurensi House Painting
Wall paintings such as this were created by women painting with their fingers or with brushes made from plants or feathers. The bold flat designs usually carried some symbolic meaning and helped identify the clan or individual living in the house. This building is dedicated to the founder of the compound. The earth colors used in this type of painting come from nature: black from plants, charcoal or soot; white from kaolin; red from camwood powder; and ochre from clay. Notice how the colors are used to create high contrast. *Gurensi people, Zuarungu compound, Northeastern Ghana. Courtesy of Fred Smith.*

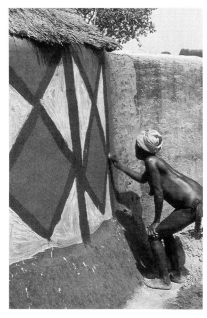

were the places where ritual objects were kept, were always fairly simple. The shrine could consist of a few forked branches set in the ground, an altar in a corner of a room, or just a place under a shady tree. Even where a small shrine house existed, worship was usually conducted in a courtyard outside it.

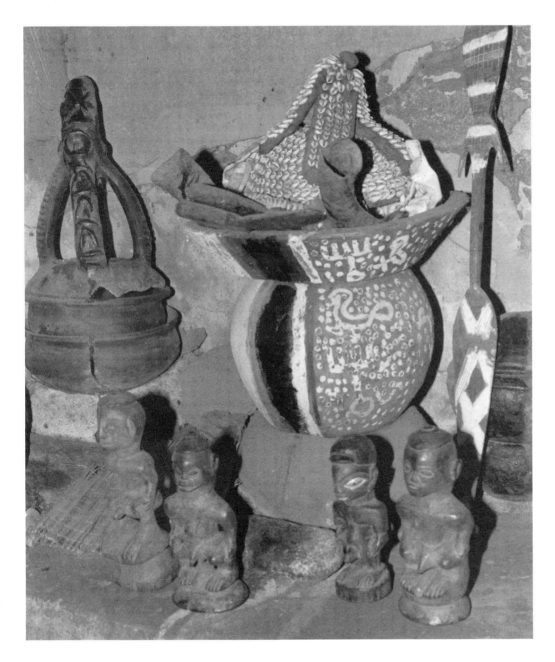

Orisha Shrine
Several different deities are represented in this shrine. Orisha Erinle, deity of hunters, is symbolized by the black terra-cotta pot on the left. Orisha Shango, deity of thunder, is represented by the large pot painted with red and white patterns. Ibeji figures, or twins, are placed in front of Shango. *Nigeria, 1982. Courtesy of J. Pemberton 3rd.*

Special Places

The decorations inside and outside places of worship often represent messages that protect the community or person to whom the shrine is dedicated. In some cultures the outside walls were decorated with high or low relief. In other cultures decorations were created by pressing natural objects such as cowrie shells into the wet clay. Sacred objects, such as pots, bowls, metal objects and small sculptures used for offerings, prayers and sacrifices were kept inside the shrine.

Today, shrine houses exist alongside modern European-style churches. In some parts of Africa, an effort has been made to "Africanize" the exterior and interior of churches by including relief-carved doors and posts. For example, Catholic church doors in Zimbabwe are often decorated with African-style relief carvings of the story of the life of Christ.

Shrine Room Entrance
Asante temples usually consisted of four rectangular rooms placed around a central courtyard that was used for ritual ceremonies. The rooms were linked together by screen walls. One of the rooms was a shrine room in which sacred objects were kept. Generally the lower part of the front outside walls of the temple was decorated with molded geometric designs while the screen walls bore open-work patterns.
Asante people, Adarkwa Kachi Village, Ghana. Courtesy of National Museum of African Art. Photograph by Eliot Elisofon, 1970.

Mosque
In cities where the predominant religion is Islam, such as in parts of West and East Africa, mosques are a common sight. Mosques in West Africa feature a minaret, which tapers toward the top and is placed on a square base. A crier calls the people to prayer from the minaret.
Banjul, The Gambia. Courtesy of Charles Miller.

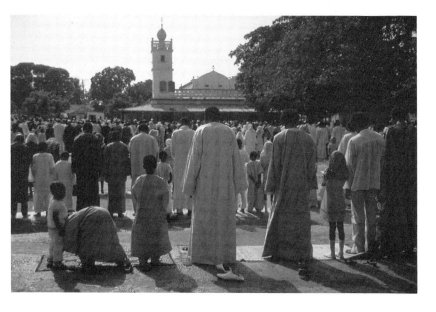

Door of a Catholic Church

This door, bordered by an "engaged post," a post that is partially embedded in the wall, is divided into panels. Each panel tells part of the story of the life of Christ. The posts are decorated with human figures placed one on top of another, totem-style. Even though the subject matter is Western, the visual content is very African. *Zimbabwe, 20th century. Courtesy of John Gillick S.J.*

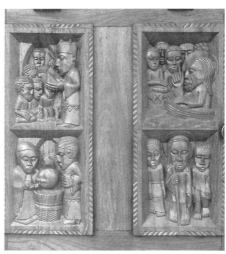

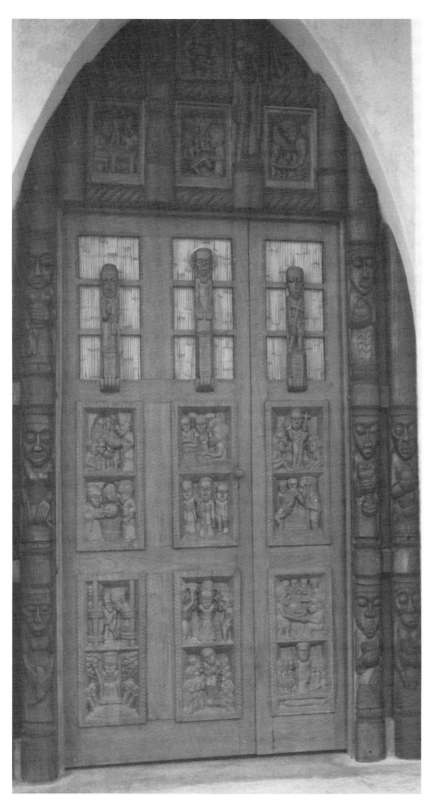

Chapter 7

FABRIC OF LIFE

*T*here is a wide variety of traditional African fabrics. Clothing revealed a lot about a person's social status. In some countries cloth was used as currency.

Because it was widely traded within and beyond the continent, cloth was very important to traditional Africans. Cloth weaving was already a part of life when the European explorers reached the mouth of the Congo River in the fifteenth century; in the sixteenth century, Europeans bought cloths woven in Benin to be used as trade items in the Gold Coast. Sometime later, Yoruba cloths were purchased for trade in Brazil.

Items made for trade were quite different from the ones woven for local use, because the trade items were often of lesser quality. Clothing worn in traditional African cultures varied from one region to another. In sixteenth century West Africa, common dress often consisted of loin clothes and blanket-like capes. By the seventeenth century, members of royalty wore more elaborately decorated clothing made from animal skins and woven cloth. Other styles introduced in the seventeenth and eighteenth centuries include the toga, which was worn by men in the area of Guinea. Men and women both wore cloths wrapped around the

Heddle Pulleys
The pulleys of horizontal looms were often ornately carved. The hornbill, baboon and buffalo were often chosen for their ritual symbolism. *From left to right, human-head and baboon pulleys from the Baule of the Côte d'Ivoire; human-head pulley from the Senufo of the Côte d'Ivoire; and Nommo pulley from the Dogon of Mali. Collection of Joseph Floch. Photograph by Arthur Efland.*

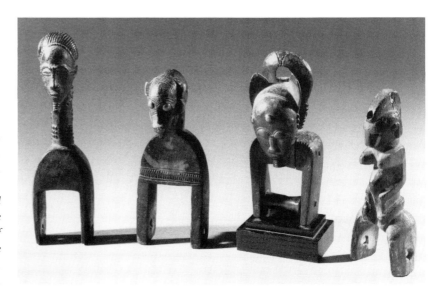

waist called pagne. Loose robes, called boubou, were worn in Senegal and Mali, and in the Sudannese area. These styles continue today, but are much more elaborate.

In traditional Africa, weaving was practiced by both men and women. In some areas, such as Ethiopia, East Africa, Zaire and most of West Africa, weaving was done only by men. In other societies, women were also allowed to weave. But while men could weave full-time, women practiced weaving as just one part of their household duties. In cultures where both men and women wove, they used different types of looms. Men used a horizontal loom and women used a vertical loom. Generally, the looms used by men had two shafts that kept the warp (threads running lengthwise) and weft (threads running crosswise) apart. The shafts were moved up and down with a simple system consisting of ropes and elaborately carved bobbins called heddle pulleys. The uppermost part of the pulley was carved in the form of a human figure, a head, or a ritual statue or mask.

Fabrics from Ghana
The patterns woven into or painted on cloth from Ghana are frequently proverbs that convey messages to friends and family. Left: If you gossip about me, you've got to sit down; top right: Don't drag me; bottom right: Change the conditions for me. *Courtesy of Anku Golloh.*

Traditionally, cotton, silk and raffia were used for weaving cloth. Cotton came from the cotton plant, while silk came from unraveling imported cloths and, in Nigeria, from the cocoons of various species of moth. Raffia cloth was made from the fiber of the raffia palm, which grows wild throughout most of central Africa. Dyes were usually made from plant sources. For example, reds came from camwood trees and henna, blues from indigo, blacks from forest mud and charcoal, and yellows from turmeric (an herb) and kola nuts. The Fulani of the inland Niger Delta region of Mali dye yarn black by boiling it with the leaves of two trees, then soaking it in mud for several days. Dyed fibers were then woven into highly decorative patterns. Kente cloth, for example, made by the Asante of Ghana, was a type of strip cloth that was valued for its rich designs. Traditionally made of dyed silk, kente cloth was only worn by royalty.

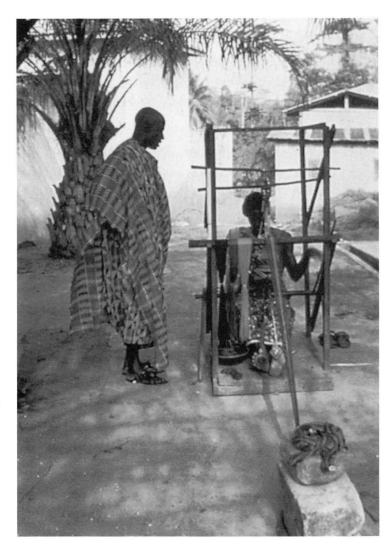

Man Weaving and Man Wearing Kente Cloth
In the seventeenth century, traditional *kente* cloth was made by re-weaving imported silk cloth that had been unraveled. Today *kente* cloth is also available in cotton. It is woven in strips of about four inches wide and three yards long. The strips are then sewn together side by side to produce a large cloth. A man's cloth has twenty-four strips, while a woman's has fourteen. *Asante people, Kumasi, Ghana. Courtesy of National Museum of African Art. Photograph by Eliot Elisofon.*

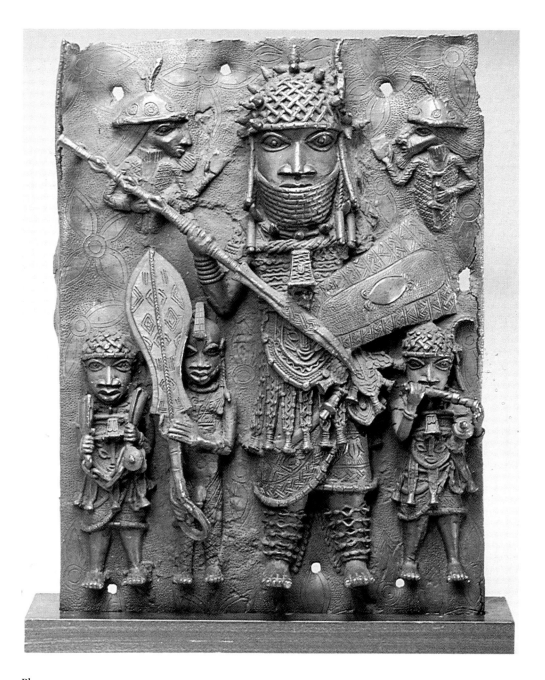

Plaque
This plaque represents a king dressed in warrior's attire. In the upper area, he is flanked by two Portuguese soldiers. A musician and two court officials are pictured on the lower part of the plaque. *Benin Kingdom, Nigeria, 16th–17th century. Cast copper alloy, 15" (38 cm). Courtesy of the National Museum of African Art. Photograph by Eliot Elisofon.*

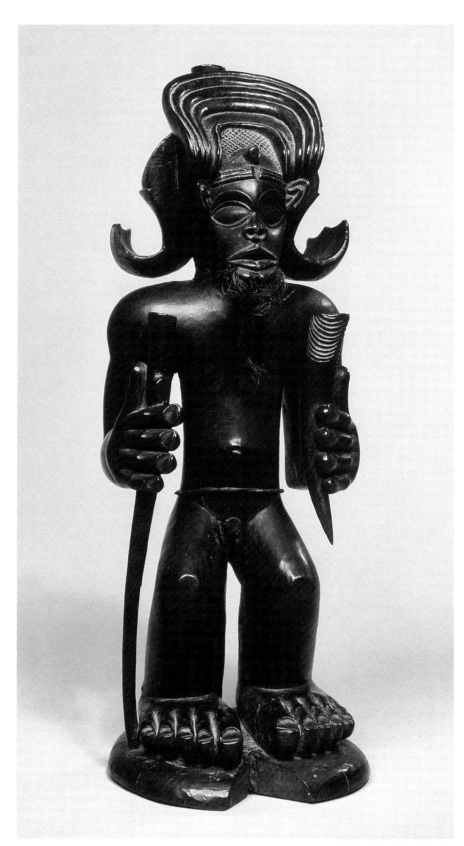

Chibinda Ilunga Katete
Notice the swelling forms of this
hunter's arms and legs. The flexed leg
stance, the presence of the headdress,
weapons and hunting bag all confirm his
cunning, hunting ability and chiefly sta-
tus. *Chokwe people, Angola, 19th century.*
Wood, 5 ¾ x 15 ¾ x 5 ¾" (15 x 41 x 15 cm).
Courtesy of Kimbell Art Museum,
Fort Worth, Texas.

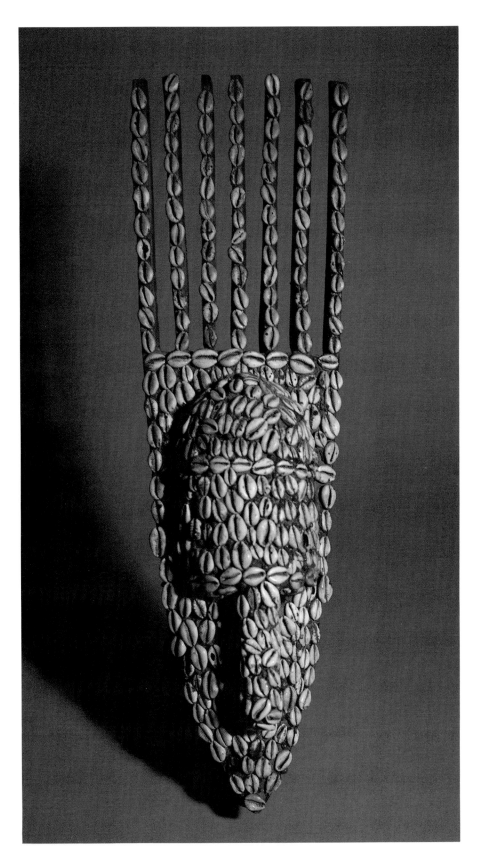

N'domo Mask
This mask is a key part of the first of six initiations, and symbolizes primordial man as an adolescent. N'domo reminds the boys of the first field cleared by human hands after the Bamana abandoned their nomadic life of hunting. *Bamana people, Mali. Wood, cowrie shells. Collection of Joseph Floch. Photograph by Arthur Efland.*

Kente Cloth

In the seventeenth century, traditional kente cloth was made by re-weaving imported silk cloth that had been unraveled. Today kente cloth is also available in cotton. It is woven in strips of about four inches wide and three yards long. The strips are then sewn together side by side to produce a large cloth. A man's cloth has twenty-four strips, while a woman's has fourteen. *Asante people, Kumasi, Ghana. Courtesy of the National Museum of African Art. Photograph by Eliot Elisofon.*

Musese Cloth
This embroidered cloth is dominated by variations of browns and yellows in irregular freehand patterns that vary in size, texture and direction. *Kuba people, Zaire, 10 ¾ x 26" (25 x 66 cm). Courtesy of the National Museum of African Art. Photograph by Eliot Elisofon, 1971.*

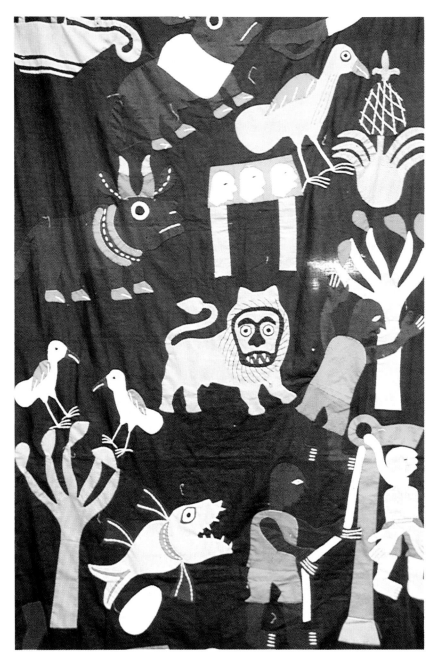

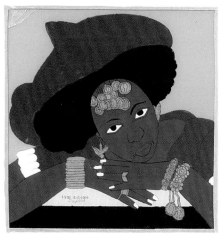

Glass Painting
The flat colored areas of this work might remind the viewer of the work of Henri Matisse. Notice that this composition is not symmetrical; the tilting hat of the woman adds an interesting touch to the composition. *Senegal. Courtesy of the Center for African Art.*

Appliquéd Cloth
The forms of the appliqués are accented by the bright contrasting colors against a black background. *Fon people, Republic of Benin. Courtesy of the National Museum of African Art. Photograph by Eliot Elisofon, 1971.*

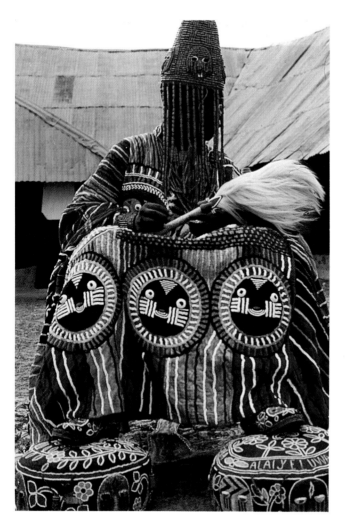

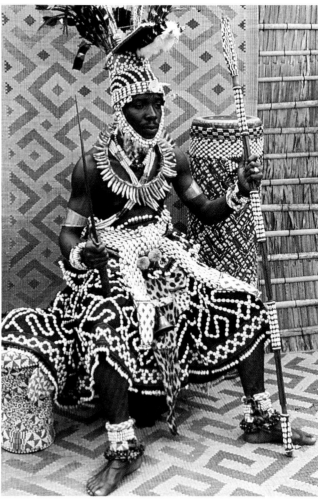

The Deji (King) of Akure in Ceremonial Dress
Although they conducted ceremonies for their people, generally African leaders were hidden from public view by either a curtain or veil. This Yoruba king shields his face with a beaded crown. The beads signify his high rank; the crown of beads indicates that his head is holy. *Yoruba people, Nigeria. Courtesy of the National Museum of African Art. Photograph by Eliot Elisofon.*

A Kuba King
This modern king, Kot a Mbweeky III, wears a headdress, a belt embroidered with cowrie shells and a royal knife. These and other pieces of chiefly finery were intended to glorify the king and impress his subjects. *Kuba people, Zaire, Courtesy of the National Museum of African Art. Photograph by Eliot Elisofon, 1971.*

Portrait of a Seated Chief
Created by S.J. Akpan, this cement memorial figure represents a deceased chief. He is portrayed in the prime of his life with bright eyes and a smiling face—a rather unusual expression for an African statue. *Cement, paint, 24' (731 cm). Courtesy of the Center for African Art.*

The East Kingdom
This painting was created by Rashid Diab. Note how the bright white areas that are dotted throughout the painting carry the viewer's eye across the picture plane. *Watercolor on canvas, 1992. Courtesy of Rashid Diab.*

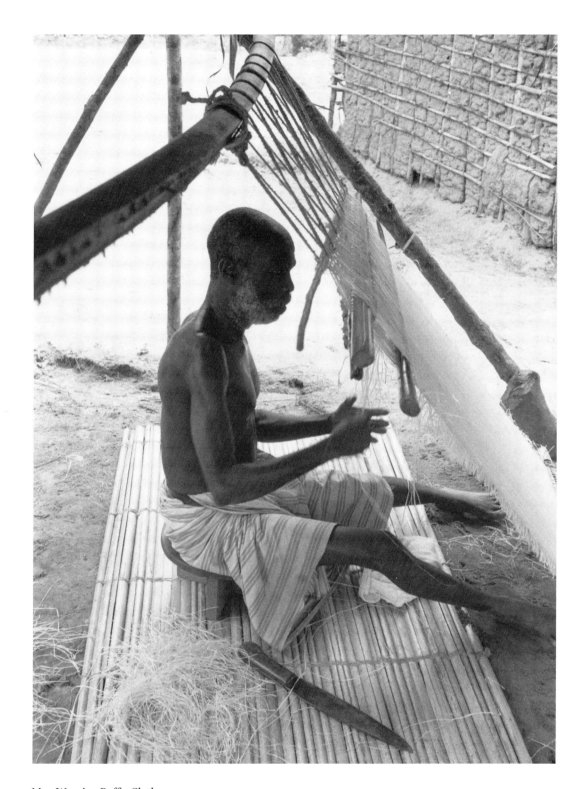

Man Weaving Raffia Cloth

In Zaire only men weave. They strip the base from the young raffia-palm leaves and beat it to separate the fibers into fine threads. These threads are then woven into a cloth on vertical-type looms located in public shelters in the streets. *Kuba people, Nemwele, Zaire. Courtesy of National Museum of African Art. Photograph by Eliot Elisofon, 1970.*

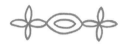

Printed & Dyed Cloth

*A*frican fabrics were frequently decorated with stamped or dyed patterns. Sometimes the designs had special meaning, and other times they were purely for decoration.

Printed cloth was made by many people of East and West Africa. In East Africa, particularly in Kenya and Tanzania, block-printed cloth designs date from the turn of the century. In West Africa, the first examples of printed cloth date from around 1817.

Block-printed fabrics were made by dipping relief-carved wooden blocks into natural dyes and pressing them onto woven cotton cloth. Probably the best known African printed fabric is adinkra cloth from Ghana. It is made the same way as block-printed fabrics, but with stamps made from pieces of calabash gourd. The stamps are cut into about fifty designs, each bearing an Asante name of historical and cultural significance. A black dye used for printing is made by boiling a special type of bark in a large kettle into which lumps of iron slag have been placed.

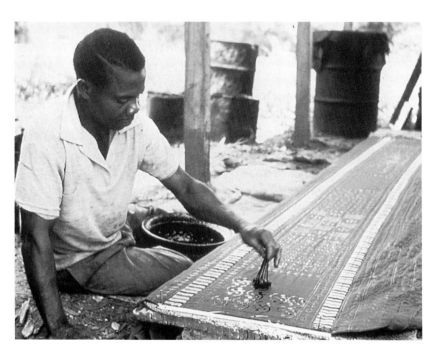

Nkoramce Adinkra Works
This man applies a stamp cut from a calabash gourd to cotton fabric. *Asante, Ghana. Courtesy of National Museum of African Art. Photograph by Eliot Elisofon, 1972.*

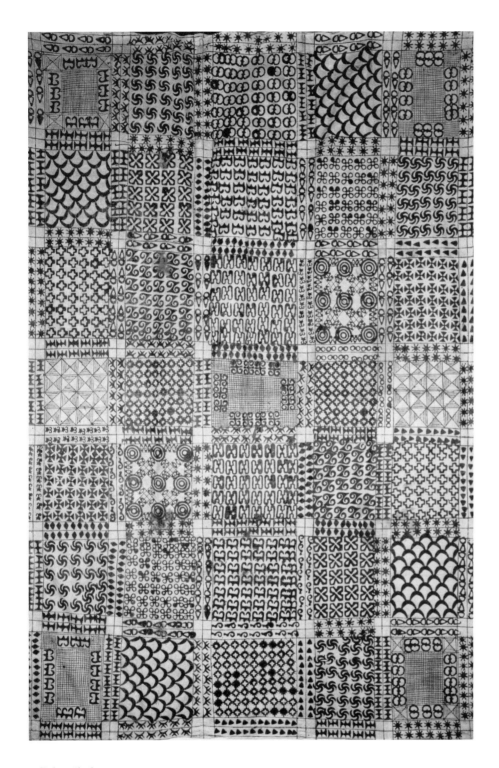

Adinkra Cloth

This hand-stamped cloth is often worn at functions for departing guests and at funeral ceremonies. (adinkra means "good-bye.") Note that there are no two sections of cloth that contain exactly the same patterns. *Akan people, Ashante group, Ghana. Cotton cloth, natural dye, 76 ¼ x 112 ¼"* *(194 x 285 cm). Courtesy of National Museum of African Art. Photograph by Spink and Son Ltd, 1983.*

Cloth could also be machine-printed, by the engraved roller process. This process consists of engraving a design on a sheet of copper called a plate. A plate was made for each color. The plates were put on a roller and rolled by machine one-by-one on the cloth. In Ghana and the Côte d'Ivoire this process is used to print cloths with wise sayings that are used to communicate feelings. Many designs used in machine-printed cloth are not African in origin: the popular kitenge cloth of Tanzania and East Africa, for example, uses flower or bird designs.

West Africans used dyes made from indigo, which came from India around 1600, to create fabrics of unusual beauty. Indigo comes from the leaves of certain plants that are pounded in a mortar to form a pulp. The pulp is then molded into balls, and allowed to dry in the sun for several days. The dried balls are combined with wood ash and then fired in a kiln for ten to twelve hours. The strength of the finished dye depends on the number of indigo balls used.

The Yoruba of Nigeria employed both tie-dyeing and a starch-resist process to create *adire* cloth—the name given to Yoruba indigo-dyed fabrics. In tie-dyeing, called *adire oniko*, patterns are made by tying the cloth in various ways. The cloth can be tied in knots, or pleated and tied with raffia, or stitched. Sometimes objects like sticks and stones are sewn into the cloth to form a resist. When the cloth is dipped into the dye, the dye does not completely penetrate the knots, tied pleats, or places where sticks and stones are sewn in. When the knots,

Khanga Cloth
This dress cloth from Malawi is usually printed with a central design and a proverb in Kiswahili. The message here has been translated into English and Nyanja (a language from Malawi), and refers to a political celebration. Typically the design includes a wide border on all four sides. *Courtesy of Jacqueline Chanda.*

Tin Stencil for Starch-Resist Dying
Yoruba men used zinc stencils cut from thin sheets of corrugated roofing for resist printing. They painted the starch paste on the cloth through the stencil and allowed it to dry before dyeing. After dyeing, the starch was removed by soaking the cloth in cold water. *Yoruba people, Nigeria. Courtesy of J. Pemberton 3rd.*

pleats and resist materials are removed, the pattern on the cloth is visible. In the starch-resist process, called *adire eleko*, patterns and designs would be drawn freehand (by women) or stenciled (by men) onto the cloth with cassava starch, a substance obtained from cassava flour. When the fabric was dyed, the dye would penetrate everywhere except the starched areas.

Bokolanfini, or mud cloth, was and is a popular commodity in Mali. Narrow strips of white cloth are dyed yellow. Mud is applied to one side of the cloth, which creates a dark background for a yellow pattern. After the cloth has dried it is dipped in water to wash off the mud. When it has dried a second time, the process is repeated. Finally, a mixture of peanuts, caustic soda, millet bran and water is applied to the cloth to remove the yellow dye. The cloth is then dried in the sun for a week. The finished cloth has a white design on a dark background.

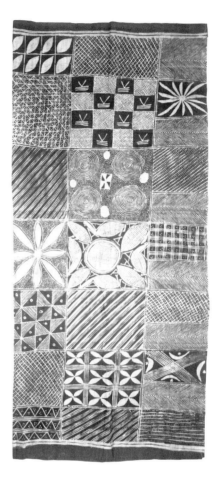

Adire Cloth
This pattern was painted freehand with starch to create a resist before dyeing. Freehand-painted cloths are generally divided into rectangles. Various geometric or other patterns may be drawn in each rectangle. *Yoruba people, Nigeria. Courtesy of the National Museum of Natural History, Smithsonian Institution.*

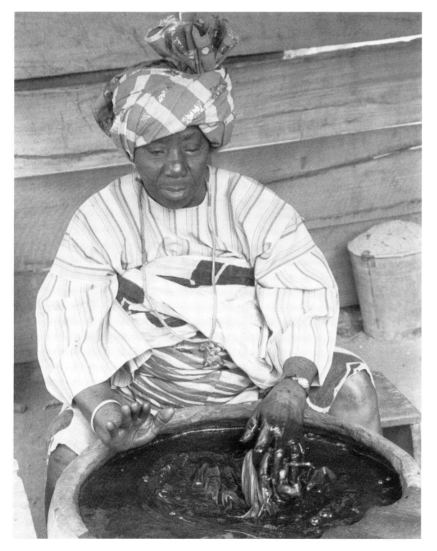

Woman Dyeing Fabric with Indigo
Indigo dyeing is performed by specialists. Indigo balls are broken up and placed in a dye pot. Ash water is poured over the pieces to make a cold dye. A piece of cloth will be dipped several times before the desired color is achieved. *Yoruba people, Nigeria. Courtesy of National Museum of African Art. Photograph by Eliot Elisofon, 1970.*

Embroidered &
Appliqué Designs

*E*mbroidered and appliquéd fabrics were frequently used to create flags, banners and other objects used for special occasions. These were more difficult to make than printed or dyed cloth.

Embroidered and appliquéd fabrics are abundant in Central and West Africa. Among the embroideries, perhaps the best known is the *musese* cloth, or raffia pile cloth, crafted by the Kuba of Zaire. This cloth is made of a base of woven raffia onto which geometric designs are embroidered. Men would weave the raffia, women would embroider the patterns and men would finish the edges of the cloth—a single cloth could take years of part-time effort to finish. To create the velvety effect, the embroidered loops were left long and then cut on one side of the cloth. The ends were then brushed so that short tufts were formed. Tight stitches sewn over the pile were used to accent and contrast the texture of some of the plush patterns. Musese fabrics were traditionally used during special ceremonies, and as clothing, blankets and stool and chair adornments for high-ranking members of the community.

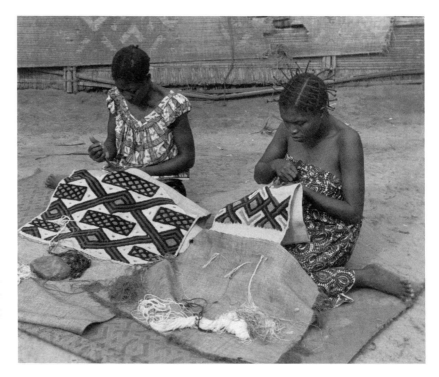

Women Embroidering Musese Cloth
The designs used in this type of embroidery are created freehand, so the patterns have a strong hand-crafted look. *Mushenge Village, Zaire. Courtesy of National Museum of African Art. Photograph by Eliot Elisofon, 1970.*

Musese Cloth
This embroidered cloth is dominated by variations of browns and yellows in irregular freehand patterns that vary in size, texture and direction. *Kuba people, Zaire, 10 ¾ x 26" (25 x 66 cm). Courtesy of National Museum of African Art. Photograph by Eliot Elisofon., 1971.*

Detail of Musese Cloth
This piece is a more contemporary example, judging from the design, which is more regular than shown in 7-14. This design is called Djume Nyimi, or "House of the King." Notice the brighter colors, which are another sign of contemporary embroidery. *Mushenge Village, Zaire. Courtesy of National Museum of African Art. Photograph by Eliot Elisofon, 1970.*

The best examples of appliqué in West Africa are from the Fon people of the Republic of Benin. Traditionally, all appliqué produced by the Fon came from members of a restricted guild located in the capital. A restricted guild is a group that works in one occupation. This one probably specializes in cloth-working. Their work included ceremonial cloth caps, hammocks and state umbrellas, as well as flags and banners. The designs and motifs used in the appliqué often shared the adventures of the individual for whom the fabric was made. The cloth-workers always kept the patterns from which appliqués were cut, because a client might want to have new flags or banners made that would include designs and images associated with his family.

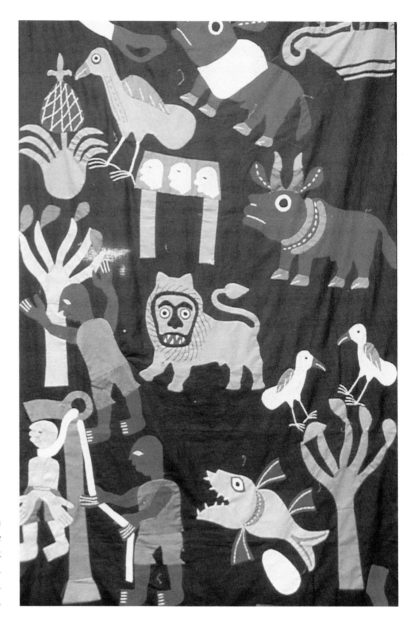

Appliquéd Cloth
The forms of the appliqués are accented by the bright contrasting colors against a black background. *Fon people, Republic of Benin. Courtesy of National Museum of African Art. Photograph by Eliot Elisofon, 1971.*

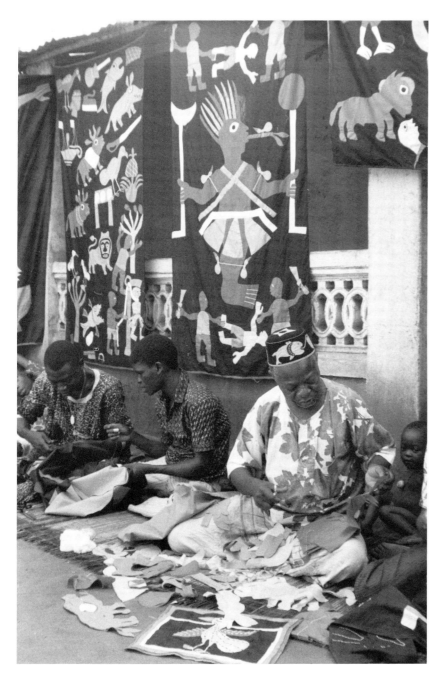

Men Making Appliquéd Cloth
Here appliqués are being cut out and sewn to a plain background cloth. *Fon people, Republic of Benin. Courtesy of National Museum of African Art. Photograph by Eliot Elisofon, 1971.*

ART & COMMERCE

*V*illages depended on successful trading with other villages. Goods produced for trade ranged from embroidered cloth and household baskets to food and raw materials, such as copper, ivory and salt.

Trading between villages usually happened when one village had something its neighbor did not, such as clay or the grass necessary for making mats and baskets. In Kubaland in Zaire, for example, the Pyaang people traded iron objects such as knives, daggers and bells for the embroidered cloth made by the Bushoong people. When goods weren't traded, it was necessary to purchase them with some form of currency. The Kuba people used cowrie shells as a form of currency; the Asante used gold dust.

Africans traded with their non-African neighbors long before the coming of the Europeans. West Africans, for example, were known to have traded with the Arabs as early as the ninth century. In central Africa, long-distance trade with Europe started shortly after the arrival of the Portuguese in the fifteenth century. Europeans were most anxious to get their hands on ivory, slaves and gold, and while searching for these items became interested in trading for African artworks as well.

Within a village the production of trade items was fairly special-

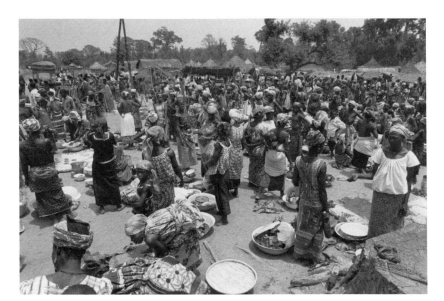

Market
The traditional market was a thriving center of business where all types of goods were bought and sold. Trading usually took place among several villages six out of seven days a week. Women typically did most of the buying and selling, while men were responsible for long distance trade. *Senufo people, Côte d'Ivoire. Courtesy of National Museum of African Art. Photograph by Eliot Elisofon, 1971.*

ized. Men and women worked together, but each had his or her particular area of responsibility. Men, for example, generally made masks, statues, stools, bellows, metal tools, knives, charms, bark cloth and musical instruments. Women typically made household baskets, engraved calabashes and pottery. In some instances men and women worked at the same craft, but in these cases they usually used different techniques and sometimes different tools.

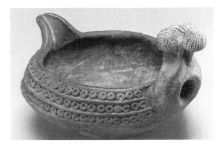

Clay Lamp
This lamp burns palm oil when a wick is floated on the surface. The spout on the left is used to drain the oil, and the knob on the right is used to hold and carry the lamp. Lamps were usually traded among neighboring villages, especially to those that did not specialize in making clay dishes and lamps. *Bamum people, Cameroon. Terracotta, 7 ⅜ x 5 ⅛" (19 x 14 cm). Courtesy of Detroit Institute.*

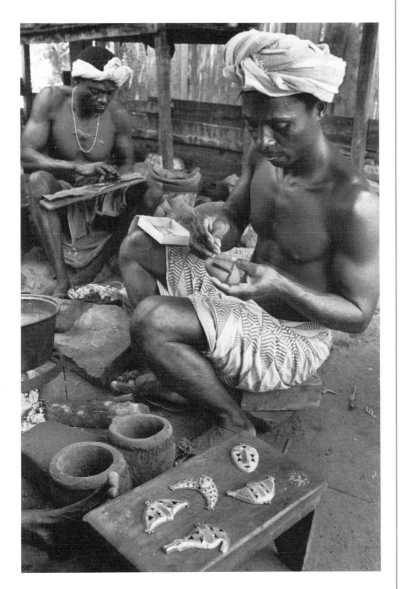

Water Vessel
Pots such as these typically have necks that end in the shape of a human head. These pots were made mainly for European markets, and to demonstrate wealth and status. Notice the pattern of dots, which covers all areas of the head except a band across the eyes. *Mangbetu, Northeastern Zaire, 1963. Fired clay, 11 ¼" (28 cm). Courtesy of Chicago Institute of Art, gift of Mr. and Mrs. James W. Alsdorf.*

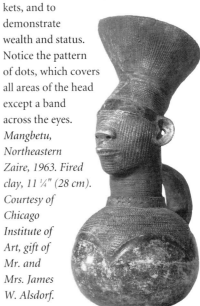

Goldsmith and Pendants
This craftsman makes pendants for trading using the lost-wax process. The goldsmith models what he wishes to make from beeswax, then covers the model with charcoal and clay. Melting the wax leaves a form which is then filled with molten gold. After the gold cools, the mold is broken and the casting removed. *Ebrie, Anna Village, Côte d'Ivoire. Courtesy of National Museum of African Art. Photograph by Eliot Elisofon, 1972.*

Pottery

*C*lay was found only in certain areas of Africa. Therefore, clay pots were an important trade item both inside and outside of the continent.

Pottery is an ancient art form. The earliest pottery discovered in sub-Saharan Africa is from Nigeria and dates from the eighth millennium B.C. The earliest known pottery from Central Africa dates from the end of the third century B.C.

In traditional Africa, the creation of pottery was surrounded by mystery. To ensure success, potters followed rules when collecting clay and creating pot forms. For example, intimacy was taboo among the Ndembu-Lunda people during their pot-making periods. In areas where clay was obtained from the river beds, the creation of pottery was a seasonal task. Pottery was produced during the dry season, when the water level of the river was at its lowest point and clay could easily be

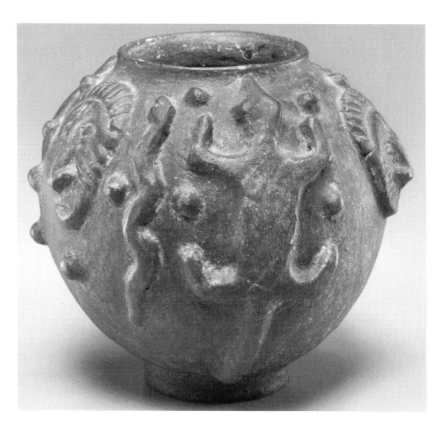

Ceremonial Vessel
Ritual pots such as this one were similar to domestic pots but usually smaller. They were generally used in connection with burials or for pouring beer or wine during a ceremony. This one is brown with traces of white. *Baule people, Côte d'Ivoire. Terra-cotta, 9 ½ x 8 ½"* *(24 x 21 cm). Courtesy of Detroit Institute.*

dug out. During the rest of the year potters devoted themselves to agricultural duties.

The skills of the potter were usually handed down from one generation to the next, from mother or mother-in-law to daughter and from father to son. Although African pottery was most often created by women, in some cultures the potters were men, and in others both men and women made pots. When both men and women produced pots in a culture, they generally used different forms and techniques. Chokwe women, for example, made domestic cooking and storage pots called

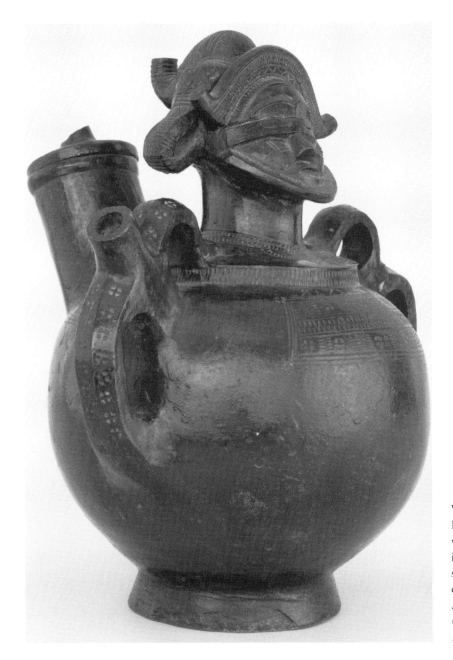

Water Pot
Double-handled water pots, called *milondo,* were used to keep water fresh. They usually incorporated figurative forms. This pot was signed by the artist, Sakadiba—a rare occurrence. *Lwena or Chokwe people, Zaire/Angola. Fired clay, 13 ⅞" (35 cm). Courtesy of National Museum of African Art. Photograph by Jeffrey Ploskonka.*

ndoho, which had simple incised geometric decorations. By contrast, the men produced highly decorative water pots called *milondo.* In addition, while the women typically built their pots by coiling long rolls of clay one atop another, the men used the molding technique. In this method, the potter uses his thumb to push an ever-larger cavity into a lump of clay; at the same time he makes the walls of the pot progressively thinner with his fingers.

Finished pots were often decorated with color or incised or stamped patterns. Sometimes they were burnished to a high sheen with a pebble or other smooth object. Figurative elements, such as heads or feet, were sometimes attached to a pot after the basic shape had been created. Once the pots had dried, they were generally low-fired, or fired at a low temperature. The pieces were placed in a shallow pit or stacked on the ground and covered with a pile of dry brush, bark and leaves, which was then lit. They were left to bake anywhere from twenty minutes to a few hours. After the pots were fired, they were coated with a vegetable substance which, together with the firing, made the pots strong and heat resistant. The coating also prevented leaking.

Coiling a Pot
In the coiling technique, the potter first creates long rolls of clay. He or she then coils the rolls on top of each other in the desired shape.
Northwestern Province, Zambia, 1982.
Photograph by Jacqueline Chanda.

Shaping a Pot
Once the coils have been stacked, the potter pushes out the sides of the pot with her hands until the walls of the pot are about ⅛″ thick. *Northwestern Province, Zambia, 1982. Photograph by Jacqueline Chanda.*

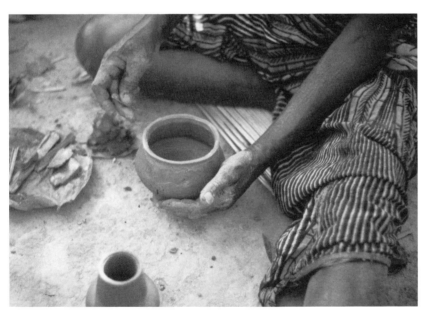

Smoothing a Pot
The surface of a coiled pot is smoothed with simple tools—pieces of bamboo, sticks, stones or fragments of gourds. *Northwestern Province, Zambia, 1982. Photograph by Jacqueline Chanda.*

Basketry

*B*oth men and women crafted baskets. Women made baskets to store and carry food; men created baskets for hunting, fishing or trading. Unlike pottery, baskets were rarely used in ceremonies.

Baskets were made only in the grassland areas, where palms, grass, and raffia could be found. They continue to be more profitable than pots as local trade and export items. Like pottery, baskets could be crafted using two techniques. Women generally used the coiling method, which produced tightly woven containers that were ideal for holding cornmeal and cassava meal. Men commonly used a weaving technique that produced a variety of geometric patterns. Regardless of the method used to make a basket, its fibers were usually dyed before coiling or weaving took place. The decorations were designed primarily to please the eye, and seem to have had no ritual or spiritual significance.

While traditional-style baskets are still being produced for local use as well as for the tourist trade, the popularity of basketry has encouraged some African basket weavers to create new, non-traditional basket forms. Craftsmen in Zambia, for example, use the bark of the bamboo tree for contemporary-style baskets that boast stylized knots and bright colors from imported dyes.

Coiled Basket
In the coiling technique, the weaver first creates a rope-like coil of twisted fibers. This coil is then wrapped with other fibers and then rolled into a circle or oval. The coil is then sewn together with raffia fibers. *Drawings by Jacqueline Chanda.*

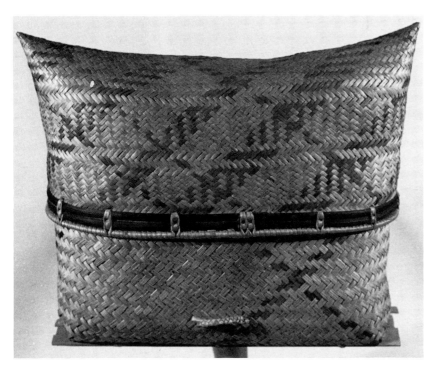

Woven Basket

This type of basket, made by men, is used to hold the clothing and other personal items of the chief, as well as medicines, masks and accessories for dance costumes. The decorative patterns are created by dying the strips of fiber before the weaving takes place. *Ndembu people, Zambia. 8 ½" (21 cm). Courtesy of the Livingston Museum, Zambia. Photograph by G. Lupiya, 1983.*

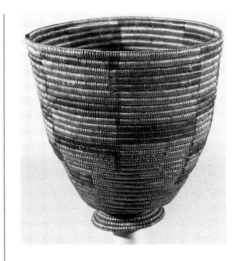

Coiled Ihebi Basket

This conical basket is used to hold cornmeal. Made by women using the coil technique, it is decorated with geometric patterns. Some baskets are so tightly coiled they can hold water. *Ndembu people, Zambia. 8 ½" (21 cm). Courtesy of the Livingston Museum, Zambia. Photograph by G. Lupiya, 1983.*

Woven Basket Patterns

Here are four variations of the weaving technique: the check pattern at upper left, the diagonal cross at upper right, the zigzag at lower left, and the hexagon at lower right. *Drawings by Jacqueline Chanda.*

Gold

Individuals from the Gold Coast, known as Ghana and Côte d'Ivoire today, panned gold from local streams and dug it from shallow mines. They used it to create jewelry and other ornaments, and to gild wooden objects. People in some parts of Africa used gold as currency as early as the 1400s.

Gold jewelry was worn exclusively by royalty or those with political status. Gold bangles, pendants, rings, necklaces and hairpins were worn on festive occasions and during special ceremonies. In general, jewelry was used for adornment and identification. It could be a sign of initiation, marriage or parenthood, or it may show rank and wealth within the community.

Traders from Europe came to the Gold Coast of Africa (Ghana) in search of gold. The gold was weighed on simple balance scales against ornate counterweights, called gold weights. The gold weights were made using the lost-wax method of casting, which was known in Africa by the ninth century A.D. In this technique, the goldsmith shapes a model of the desired object in beeswax and covers it with charcoal and clay. Melting the wax leaves a mold which is then filled with molten metal. After the metal hardens, the mold is broken to release the weight.

Gold weights from the Ashanti people of Ghana were made in two forms—geometric and figurative. The geometric weights date from 1400 to 1700, while the figurative ones date from 1700 to 1900. Geometric weights varied in shape and size, from simple rectangular blocks to crescents, circles and triangles. The shape of figurative weights also varied. Important chiefs used gold weights as part of their state treasuries and on behalf of their states during times of war, large cele-

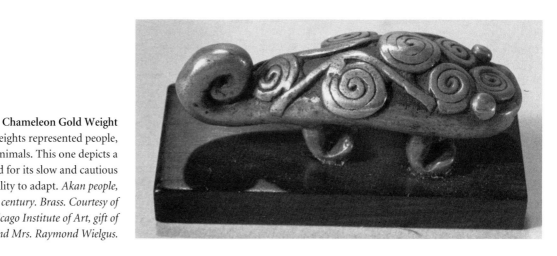

Chameleon Gold Weight
Figurative gold weights represented people, insects or animals. This one depicts a chameleon, noted for its slow and cautious movement and its ability to adapt. *Akan people, Ghana, 20th century. Brass. Courtesy of the Chicago Institute of Art, gift of Mr. and Mrs. Raymond Wielgus.*

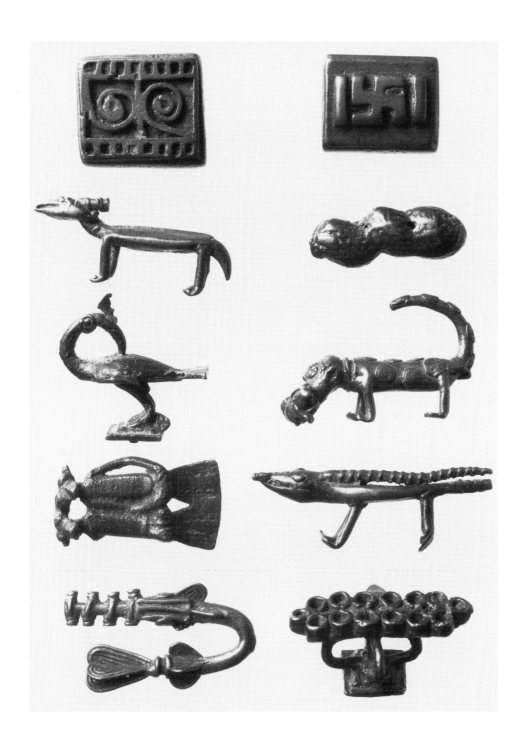

Gold Weights

Geometric gold weights with stamped or engraved decorations are some of the oldest examples, and are larger than the figurative type. Gold weights modeled after nature had meaning. The peanut, for example, related to the bounds of marriage. Animal designs signified characteristics of that animal. A bird looking back may mean beware of what is happening behind you as well as in front of you. *Akan people, Ghana. Courtesy of the Smithsonian Institution Museum of Natural History.*

brations or royal funerals. Chiefs could send certain weights to other people to communicate proverbs and wise sayings. For example, crabs are feared because of their claws. By sending a crab claw weight, one chief may be telling another that his state would rather fight than submit. Graduated weights were used by traders for everyday transactions.

As beautiful as they are, gold weights had no spiritual significance. Many weights did, however, carry proverbs that were connected with the daily life of the common person or the life of the chief and nobles.

The manufacture and use of gold weights declined rapidly after the British conquest of the Gold Coast in the late nineteenth century, because the British replaced the gold currency with their paper currency. By 1920, if not before, weights were being made almost solely for sale to Europeans.

Catfish Gold Weight
With its sharp, serrated spines, the catfish was related to a proverb warning of dangerous men (or chiefs). Many gold weights related to proverbs. *Asante, Ghana, 20th century. Brass, 2" (5 cm). Courtesy of the Chicago Institute of Art, Gift of Alfred Wolkenberg.*

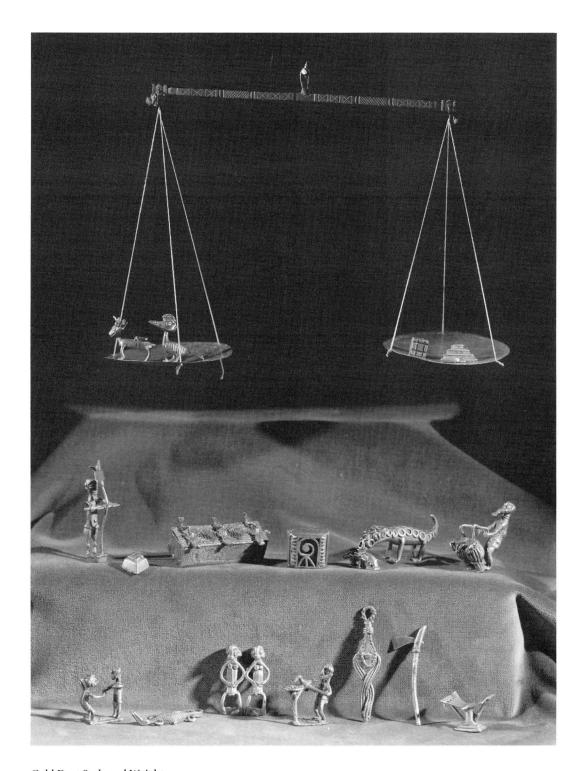

Gold Dust Scale and Weights

Gold dust was weighed on scales very much like this Asante one. The dust was placed on one side of the scale, and the counterweight on the other. Notice that even the fulcrum of the scale is decorated with linear patterns. Although all Akan peoples used gold weights, the Asante, a sub-group of the Akan, were famous for their manufacture and use. *Akan people, Ghana. Courtesy of the University Museum, University of Pennsylvania.*

Tourist Art

Africans began to create objects designed just to please Europeans as early as the 1500s. These objects are called "tourist art." They are not related to the values and functions of traditional African artworks.

The tourist trade—and the start of commercial business—is an important factor in the economy of many African states. The trade of tourist objects began very early in the history of many African countries. In the sixteenth century, for example, Portuguese traders are known to have hired West African craftsmen to make ivory carvings simply to take home as souvenirs. These salt cellars, spoons, dagger handles and forks fit the needs of the Europeans—not the Africans—

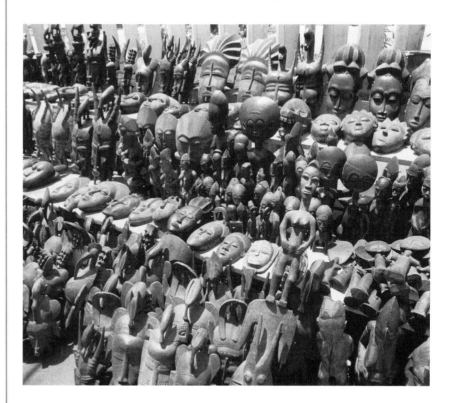

Street Sculptors
Tourist objects are often made by carvers working under assembly-line conditions. These carvers work on the street or sometimes in warehouses as part of a group. *Accra, Ghana. Courtesy of Charles Miller.*

Tourist Art
This street stand sells copies of traditional and contemporary styles of art objects. The traditional carvings represented here are somewhat different from those used for traditional purposes. Generally, they are made from heavier wood and the details are simplified. *Bouake, Côte d'Ivoire. Courtesy of National Museum of African Art. Photograph by Eliot Elisofon, 1972.*

but the African craftsmen responded to the market as do craftsmen all over the world.

The demand for tourist-type objects grew even larger in the seventeenth and eighteenth centuries, as Europeans continued to enter the continent of Africa. The demand is now so high that objects are no longer made by one hand but are mass-produced by many. In sculpture "factories," carvers work on what might be called an assembly line: one person carves the basic form, another carves the limbs, while still another may add the details.

Many African carvers have formed associations which sell their works to the public. In other countries, the government encourages and gives money to support the creations of cottage industries for the purpose of producing art objects for the tourist market. Items for trade may also be sold to dealers who travel long distances, sometimes by foot, bicycle, bus or plane, to sell their items in the marketplaces of Europe, America and Africa.

Initially tourist art ignored the subjects and styles of traditional art. So tropical animals, plant life and African scenes were realistically portrayed. Over the past fifty to sixty years, however, the interest of the tourist has expanded to include objects, such as masks and sculptures, from traditional product lines. Copying such traditional forms has been encouraged by museum workshops. For example, in the city of Abidjan in the Côte d'Ivoire, sculptors are employed to reproduce for visitors select items from the museum's permanent collection.

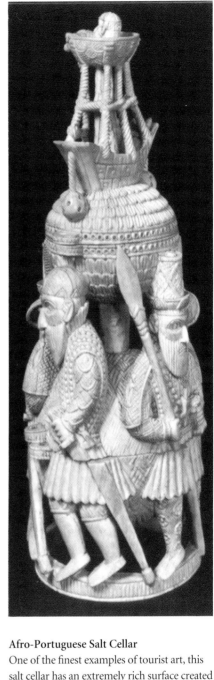

Afro-Portuguese Salt Cellar
One of the finest examples of tourist art, this salt cellar has an extremely rich surface created by intricate patterns. Two senior Portuguese officials and two attendants support the bowl. *Benin people. Ivory, 11 ¾" (30 cm), 16th century. Courtesy of the British Museum.*

Realistic Giraffe
Sculptures depicting African wildlife were and are popular. These kinds of figures are produced in a relatively small tribal area of Kenya. They range in size from six to sixteen inches and are usually slick, well-polished forms, made out of fairly hard dark brown wood. *Wakamba, East Africa. Courtesy of the Smithsonian Institution.*

AFRICAN ART TODAY

Chapter 9

Many of today's African artists use Western methods and materials in their work. Likewise, imagery has expanded to include both African and Western themes.

Contemporary African artists excel in media that were not a part of their tradition. We find them painting on non-traditional surfaces such as cardboard and canvas with bright, bold colors purchased from the Western market. We find them producing etched or serigraph prints. We find them sculpting images that are realistic rather than idealized.

Another non-traditional art form is billboard art. In the 1920s, mural paintings took their place on the walls of urban homes; today, billboards and the walls of businesses are painted with images to attract clients. The images are highly figurative and painted in a style that reflects Western concerns of realism. This style of wall painting originated in the colonial cities, but has spread to smaller towns and villages. These advertisements are all painted by men.

Painting on glass, another non-traditional medium, became popular in Senegal in the 1950s. The practice seems to have come from Islamic countries in the North at the turn of the century. The popularity of glass painting grew in Senegal because it was an inexpensive way of copying photographs, chromoliths and postcards for home decoration. The subject matter of these glass paintings—devotional scenes, political figures, historical scenes, or scenes of everyday life—are outlined in black on the underside of a piece of glass. Then the outlined areas are

Urban Billboard
This billboard is advertising a hair salon. The sign says "modern braids" and shows the variety of hair styles available. *Fon people, Cotonou, Republic of Benin. Courtesy of Charles Miller.*

114

filled in with strongly colored flat enamels. Because the images are taken from photos and postcards, the glass paintings are fairly formal and usually symmetrical. Glass painters are typically self-taught or trained through an apprenticeship system under the guidance of a studio master. This art form, which was initially created for local use, has become a tourist commodity and today is mainly purchased by foreigners.

Easel painting as an art form was unknown in traditional Africa. It was stimulated by various European type art schools that thrived in many African countries from the 1920s to the 1960s. In schools such as the Academie des Beaux-Arts et des Metiers d'Art in Zaire, gouache, oil and acrylic paints are used to express different ideas of self and society.

Advertisement
This is a medicine man's advertisement. Notice how the realistic rendering contrasts with the flat space of the background. *Fon people, Cotonou, Republic of Benin. Courtesy of Charles Miller.*

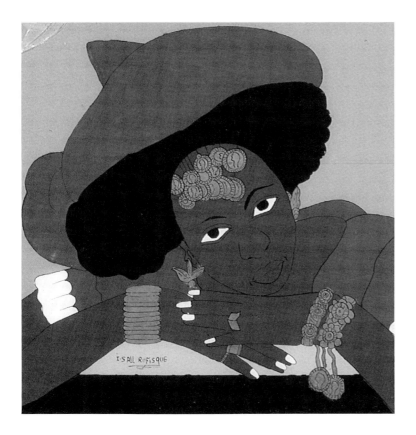

Glass Painting
The flat colored areas of this work might remind the viewer of the work of Henri Matisse. Notice that this composition is not symmetrical; the tilting hat of the woman adds an interesting touch to the composition. *Senegal. Courtesy of the Center for African Art.*

African paintings may be categorized as either urban or international. Urban paintings, usually created for local use, generally reflect the changes taking place in the urban areas of certain African countries. In Zaire, for example, paintings reflect themes that relate to colonial oppression and local historical, social and political events. Zairian urban artists are either locally trained or self-taught. The style in which these artists work is flat, with little modeling, and cartoon-like. The colors are bold and strong.

International paintings are those created by artists who have been inspired by many different sources. They are often trained in American or European schools, and show their work internationally as well as in local exhibitions. While the work of these artists may be recognizably "African," some of it may look more European than African and have virtually nothing to do with African themes or traditions.

Paintings reflecting African influences usually incorporate designs taken from traditional house paintings, symbols, textile designs and regional patterns. Perspective and spatial depth, modeling and shadows

Billboard
This example of urban art is a publicity piece for a medical consultant or doctor. Notice the cartoon-like quality of the figures, and the artist's use of the voice and vision bubbles and type. *Courtesy of Charles Miller.*

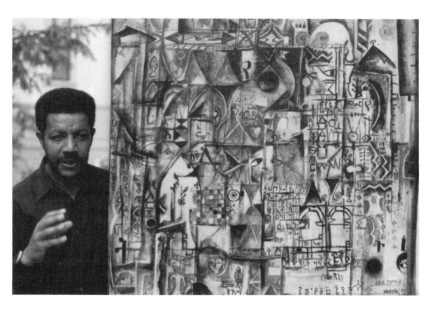

The New Alphabet
This painting by Ethiopian artist Wosene Worke K. is heavily rooted in the African experience. It uses Ethiopian alphabet symbols for their intrinsic magic and their literal and symbolic significance, as well as visual forms from other parts of Africa. There are silhouettes of Senufo statues and Fang masks, and pictographic images that recall Egyptian art. *Acrylic on canvas, 1991. Courtesy of Wosene Worke K.*

are not issues—patterns and design are the primary concerns. A good example of this type of painting is the work done by Wosene Worke K., an Ethiopian artist who uses the 221 alphabet symbols from the Ethiopian language as design elements; he also is influenced by famous sculptural forms from West Africa. Wosene Worke K. obtained his Bachelor of Fine Arts degree from the School of Fine Arts in Addis Ababa in 1972. He taught painting and drawing there until 1978, when he traveled to the United States. He received his Master of Fine Arts degree from Howard University's College of Fine Arts in 1980. He now lives in California.

Addis Zemen
Wosene Worke K. relies on the use of the Ethiopian alphabet, in large letterforms and blocks of text, to create this contemporary piece. According to the artist Ethiopian religious paintings also incorporated church language when portraying religious stories. *Mixed media on canvas, 17 x 19". Collection of Yosias and Beleta.*

She Ethiopia III
Here artist Wosene Worke K. arranges African motifs in an unusual manner. Certain aspects of the intersection of geometric shapes may recall the cubist stage of Picasso and Braque. *Acrylic on canvas, 1991. Courtesy of Wosene Worke K.*

African Art Today

There are many other renowned African artists whose work reflects African themes. Among them is Ouattara, an Ivoirian born in 1957. Currently living in New York City, Ouattara's work blends African, Egyptian and post-Modern images. Another example is Bruce Onobrakpeya, a student of Ben Enwonwu (one of the first African artists to have his work exhibited in Europe). He uses African imagery inspired by Nigerian legends and folktales. Born in Nigeria in 1937, he attended both Nigerian and European schools, and has been a full-time artist since the 1960s. He works primarily in bronze relief and prints. In addition, many African artists combine traditional techniques and images with contemporary ones. Sudanese artist Rashid Diab, for example, finds freedom in mixed media and watercolors—his work ranges from watercolor paintings to monoprints and etchings.

The women of Mali, who still paint bokolanfini, or mud cloth, have expanded their array of motifs to include historical or village scenes. Pama Sinatoa, for example, a Malian mud-cloth painter, has converted the traditional medium into a unique personal expression. She paints scenes that reflect her Moslem heritage, as well as the traditions of the people of Mali.

Men and women in Africa also create batik, or wax resist, images. Similar in technique to adire eleko, the starch resist method of dyeing, this form of textile art is meant to be hung on a wall, like a painting. Nike Davies, for example, uses this non-traditional medium to combine traditional African patterns and themes with her own ideas, and paint scenes that reflect her heritage. Davies was born in Ogide, Nigeria in 1951. She left home at the age of 16 to join a traveling theater group, where she met her husband, Twins Seven Seven. He taught her the art of batik and how to draw, and encouraged her to develop her talent. She

Hunter's Masquerade
This print by Bruce Onobrakpeya, created in 1989, has a curvilinear flow. There is an interesting play of textured and non-textured surfaces. Notice the traditional African elements that have been incorporated into this piece. *Plastograph, 7 ½ x 8 ¾" (19 x 22 cm). Courtesy of Janet Stanley.*

Lover Birds with Their Enemy
Random capillaries of color happen naturally in batik. They are left by dye that has seeped through cracks in the wax resist. Here they add texture to the circular and linear patterns in the birds and snake. The birds in this painting by Nike Davies may represent roosters, which have a noted presence in Nigerian mythology. *Nigeria, Batik. Photograph by Juliet Highet.*

later attended the Oshogbo School in Nigeria. Her designs have become increasingly sophisticated and are popular world-wide. Today, Davies continues to work in her home in Nigeria.

Contemporary African artists are beginning to receive more recognition. But to simplify their access to the international market, many choose to live outside their countries.

Arugba
African batik paintings often include images that draw from history or village scenes. This piece by Nike Davies reflects inspiration from Nigerian mythology and everyday life. *Nigeria, Batik. Photograph by Juliet Highet.*

The East Kingdom
This painting was created by Rashid Diab. Note how the bright white areas that are dotted throughout the painting carry the viewer's eye across the picture plane. *Watercolor on canvas, 1992. Courtesy of Rashid Diab.*

Sculpture

Sculpture is one of the oldest art forms in Africa. Today it is made both to serve traditional and contemporary purposes. It may make use of traditional or new materials. And it may be made by men or women.

The emergence of European-inspired art forms doesn't mean that traditional forms have ceased to exist. But changes have taken place. Many contemporary ritual masks, for example, incorporate Western imagery or materials. A traditional Gelede mask, used by a Yoruba men's association to honor the special powers of women, may incorporate a motorcyclist. The traditional colors of red, white and black used on a Guro dance mask may be replaced with bright enamels. Contemporary fertility images may be more realistic than traditional conventions allowed.

Osei Bonsu (1900–1977) was one "traditionalist" artist whose commissions allowed him to work in an innovative style. This Asante carver worked for the Asante king as well as for many other people. His

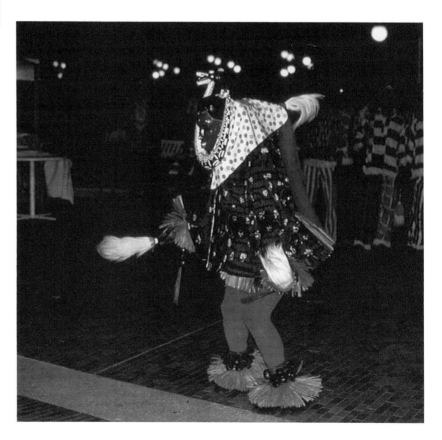

Contemporary Guro Mask
This mask, created in 1978, features naturalistic features and a smiling face. *Wood, pigment. Courtesy of the Center for African Art.*

works included crowns, sword handles, staffs, sculptures used in shrines and tourist pieces.

Other artists sometimes use Western materials in a Western style to express traditional concepts and fulfill traditional functions. In Nigeria, for example, artists make life-size and larger-than-life-size cement statues as memorials to the dead. These statues are created for second burial rites, which take place several months to a few years after someone's death. The figures, which are dressed in contemporary clothing, are very realistic and are generally made for wealthy chiefs. They are placed on tombs near the deceased's home.

S. J. Akpan is a prominent artist who works in cement. A self-taught sculptor, Akpan initially advertised his work by placing it on display along the main road where he lived. Akpan uses a combination of casting and molding for his memorial figures; he also makes crucifixes, cement lions and other animals for the tourist trade.

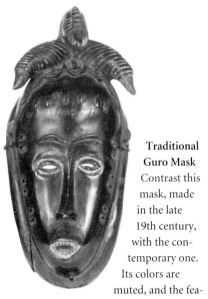

Traditional Guro Mask Contrast this mask, made in the late 19th century, with the contemporary one. Its colors are muted, and the features, though more finished, are not as realistic. *Wood, pigment. Courtesy of Charles Mack.*

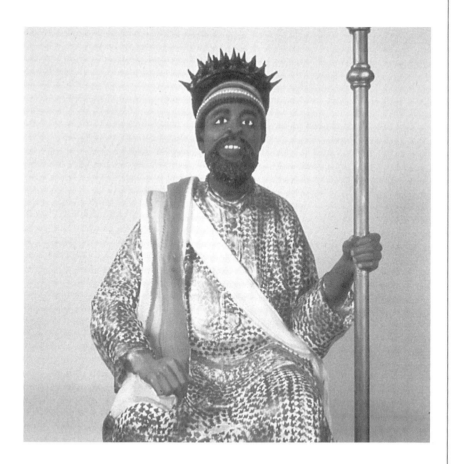

Portrait of a Seated Chief
Created by S.J. Akpan, this cement memorial figure represents a deceased chief. He is portrayed in the prime of his life with bright eyes and a smiling face—a rather unusual expression for an African statue. *Cement, paint, 24' (731 cm). Courtesy of the Center for African Art.*

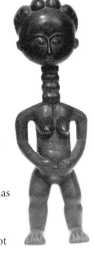

Akua'ba **Figurine**
Carved for an American patron, this fertility sculpture carved in the manner of Osei Bonsu has a naturalistic form. The legs and arms are full-bodied and the face is not flat but has a three-dimensional character. Traditionally, statues like this would be used to encourage pregnancy and ensure the birth of a healthy baby. *Akan people, Ghana, 1976. Wood. Courtesy of Charles Mack.*

GLOSSARY

Abusuwa kuruwa — a family pot used to hold hair and nail clippings of family members together with those of the deceased.

Adinkra — a cloth worn at funerals by the Akan people of Ghana. The word "adinkra" literally means "farewell" or "separated."

Adire — a technique used to dye cloth. *Adire oniko* refers to a tie-dye process; *adire eleko* is a starch-resist technique.

Aerophone — an instrument played by blowing, such as a flute, whistle or trumpet.

Adze — an axe-like tool with a curved blade used to trim and smooth wood.

Agere ifa — a divination cup.

Akua'ba — a wooden fertility image, traditionally used by women in Ghana to induce pregnancy and ensure the safe birth of a healthy baby.

Autonomous village — an independent, self-governing village.

Babalawo — a Yoruban soothsayer or diviner.

Badie — a type of dye used to color clothes.

Bokolanfini — "mud cloth," or cloth decorated through the use of mud.

Burnishing — the act of polishing unfired clay with a pebble or cloth.

Bwiiti — a figure representing clan founders. The figure guards the skull and certain other bones of Hongwe ancestors.

Calabash — a type of gourd used to make eating and drinking implements.

Camwood — a reddish wood often ground into powder for use as a cosmetic or ointment.

Chameleon — a lizard having the ability to rapidly change its skin color.

Cassava — a starchy tubular root plant that is a staple food item in many African countries.

Caste — a term designating a restrictive social or occupational organization of people.

Centralized government — a government that organizes people under a central ruler.

Chordophone — an instrument played by vibrating a string, such as a harp.

Cowrie shells — mollusk shells used as currency in many parts of Africa and South Asia.

Deble — a statue used by the Senufo of the Côte d'Ivoire to pound rhythms during certain stages of commemorative funerals and during the ten Poro ceremonies devoted to fertility.

Decentralized government — a government that organizes people under a variety of leaders.

Eben — a flat, symmetrically pierced sword.

Edan — the male and female primordial couple of the Yoruba of Nigeria.

Engaged post — a post or structure that is partly embedded in a wall.

Ere ibeji — a statue or statues representing deceased twins from the palace.

Figurative gold weights — gold weights depicting groups of people interacting in daily activities, made by the Akan people of Ghana.

Frontal — a term used to describe sculptural figures having a stiff formal pose, with hands at the sides and eyes facing forward.

Gelede — masquerade dances intended to placate witches by entertaining them.

Genre — images in which subjects or scenes from everyday life are treated realistically.

Griot — a person who is at once a singer, storyteller and historian from West Africa.

Hausaland — a cluster of states which grew up around several towns north of the Niger-Benue confluence.

Heddle pulleys — devices used to raise and lower the cords in the harness of a loom.

Ibeji — the deity of twins.

Ibol — an object carved in full relief and placed before the ruler, to symbolize his reign.

Idiophone — an instrument played by striking, such as a sanza, thumb piano or slit gong.

Ifa — divination.

Ikenga — a carved wooden statue depicting a well-developed human figure, thought by the Kalabari Ijo people of Nigeria to ensure good fortune.

Intaglio — a design or figure carved, incised or engraved into a hard material.

Indigo — a blue dye obtained from certain plants.

Itombwa — a divination object or friction oracle used by the Kuba people of Zaire.

Janus — a double-faced figure renowned in Roman mythology.

Kaolin — a fine white clay used in ceramics.

Kente — a richly colored cloth.

Kinship — denoting family members of the lineage or clan.

Kolanut — the seed of the cola tree. The caffeine extracted from this seed is used in drinks and medicines.

Labret — an ornament of wood, bone, or other material worn in a hole pierced through the lip.

Linguist — a person accomplished in language, usually retained to translate the king's words.

Lost-wax process — a casting technique in which a shaped wax core is covered with clay and heated until the wax melts out. The wax is replaced by molten metal. When the metal has cooled, the clay mold is removed.

Mbulu Ngulu — a reliquary figure used by the Kota of Gabon to guard the bones of important deceased people.

Membranophone — an instrument played by vibrating the membrane or skin, such as a drum.

Milondo — a water pot used by the Chokwe of Ambia and Angola.

Minaret — a high slender tower attached to a Moslem mosque, with one or more projecting balconies from which a crier calls people to prayer.

Mma — commemorative terra-cotta portraits of Anyi and Abure royalty of the Côte d'Ivoire and Ghana.

Musese — velvet or pile cloth made in the Kuba region of Zaire.

Ndoho — a water pot used by the Ndembu of Zambia.

Ndop — a carved wooden portrait statue commemorating Kuba kings.

Neckrest — a device used to protect a hairstyle while sleeping.

Niger-Benue — two rivers that converge in southern Nigeria.

Oba — a Yoruba king.

Ofika — figure or figures that represent initiates who broke the laws of the Lulua from Zaire.

Ogboni — a secret society responsible for civic order.

Orisha — the spirit or spirits of deified ancestors, who link mortals with the spirit world and encourage them to act correctly on earth.

Owu — a water spirit or spirits who bless humans with fertility and ensure the food supply.

Patina — a fine crust or film that coats an artwork, changing its color.

Pelambish — royal drums of the Kuba of Zaire.

Polychrome — decorated with several colors.

Poro — a Liberian men's association, responsible for the initiation of young boys.

Puddling — the process of working clay or a similar substance with water, resulting in a sturdy building material.

Relics — surviving fragments of bones.

Reliquary — a small box or basket in which relics are kept.

Sedentary — the act of staying in one place for long periods of time.

Shea butter — a thick, white fat, used as a food and to make soaps, extracted from seeds of an African tree.

Terra cotta — a brownish-orange clay used especially for statuettes and vases, and for architectural purposes.

Thatch — a roof made from straw, palm leaves, or other vegetative material.

Warp — the threads running lengthwise in the loom when weaving.

Weft — the threads carried by the shuttle back and forth across the warp when weaving.

BIBLIOGRAPHY

Readers should note that several of the books listed in this bibliography may be out of print and will not be available in bookstores. Those of you interested in purchasing out-of-print books may be able to locate them through rare book search services. Otherwise, we recommend that you check with your local library.

Adams, M., "Beyond Symmetry in Middle African Design," *African Arts*, 23(1):35–45, 1989.

Azevedo, W. L. (ed.), *The Traditional Artist in African Societies*. Bloomington: Indiana University Press, 1975.

Balandier, G. and J. Maquet, *Dictionary of Black African Civilization*. New York: Leon Amiel, 1974.

Barnes, S. (ed.), *Africa's Oqun: Old World and New*. Bloomington: Indiana University Press, 1989.

Bascom, W., *African Art in Cultural Perspective: An Introduction*. New York: W. W. Norton & Company, 1973.

Bastin, M. L., *Art Decoratif Tshokwe*. Lisboa: Companhia de Diamantes de Angola, 1969.

Brain, R., *Art and Society in Africa*. London: Longman, 1980.

Brincard, M. (ed.), *Sounding Forms: African Musical Instruments*. New York: American Federation of Arts, 1989.

Campbell, J., "The Way of the Animal Power," Vol. I. San Francisco: Harper & Row.

Carroll, K., *Yoruba Religious Carving: Pagan and Christian Sculpture in Nigeria and Dahomey*. New York: Frederick A. Praeger, 1967.

Cole, H. M., *Icons, Ideals and Power in the Art of Africa*. Washington, DC: National Museum of African Art, 1989.

———, "Mbari Is a Dance," *African Arts*, 11(4):42–51, 1969.

Courtney-Clarke, M., *African Canvas: The Art of West African Women*. New York: Rizzoli, 1990.

Davidson, B., *A Guide to African History*. Garden City: Doubleday and Company, 1965.

Denyer, S., *African Traditional Architecture: An Historical and Geographical Perspective*. London: Heinemann, 1982.

Drewal, M. T. and H. J. Drewal, "Gelede Dance of the Western Yoruba," *African Arts*, 8(2):36–45, 1975.

Fagg, W., J. Pemberton and B. Holcombe, *Yoruba Sculpture of West Africa*. London: Collins, 1982.

Gebauer, P., *Art of Cameroon*. New York: Portland Art Museum, 1979.

Gillon, W., *A Short History of African Art*. Middlesex: Penguin Books, 1984.

Glaze, A. J., *Art and Death in a Senufo Village*. Bloomington: Indiana University Press.

Highet, J., "Five Nigerian Artists," *African Arts*, 2(2):34–41, 1969.

Holcombe, B. (ed.), *Yoruba Sculpture of West Africa*. London: Williams Collins Sons & Co., 1982.

Imperato, P. J., "Door Locks of the Bamana of Mali," *African Arts*, 5(3):52–56, 1972.

Kennedy, J., "Bruce Onobrakpeya," *African Arts*, 5(2), 1972.

———, "Wosene Kosrof of Ethiopia," *African Arts*, 20(3):64–67, 1987.

LaDuke, B., *Africa Through the Eyes of Women Artists*. New Jersey: African World Press, Inc., 1991.

Laude, J., *The Arts of Black Africa*. Los Angeles: University of California Press, 1971.

Lehuard, R., "Le Sande: a la Galerie Balolu," *Arts Premiers*, Spring, 1971.

Mbiti, J. S., *Introduction to African Religion*. London: Heinemann, 1975.

McLeod, M., *Treasures of African Art*. New York: Abbeville Press Publishers, 1980.

Mount, M. W., *African Art: The Years Since 1920*. Bloomington: Indiana University Press, 1973.

Nicklin, K. and J. Salmons, "S. J. Akpan of Nigeria," *African Arts,* 11(1):30–34, 1977.

Olaniyan, R. (ed.), *African History and Culture*. Lagos: Longman, 1982.

Parrinder, G., *African Mythology*. New York: Peter Bedrick Books, 1987.

Peek, M. P., *African Divination Systems: Ways of Knowing*. Bloomington: Indiana University Press, 1991.

Picton, J. and John Mack, *African Textiles: Looms, Weaving, and Design*. London: The Trustees of the British Museum, 1979.

Ravenhill, P. O., "Baule Statuary Art: Meaning and Modernization," *Working Papers in the Traditional Arts*, No. 5, 1980.

Robbins, W. M. and N. I. Notter, *African Art in American Collections*. Washington, DC: Smithsonian Institution Press, 1989.

Ross, D., "The Art of Osei Bonsu," *African Arts,* 27(2):29–40, 1984.

Roy, C., *Art and Life in Africa*. Iowa: University of Iowa, 1985.

Schildkrout, E., J. Hellman and C. Keim, "Mangbetu Potter: Tradition and Innovation in Northeast Zaire," *African Arts,* 22(2):38–47, 1989.

Schreckenbach, H., *Construction Technology for a Tropical Developing Country*. Eschborn: German Agency for Technical Cooperation, 1980.

Sieber, R. and R. A. Walker, *African Art in the Cycle of Life*. Washington, DC: National Museum of African Art, 1987.

Smith, F. T., "Gurensi Wall Painting," *African Arts,* 11(4):36–41, 1978.

Steiner, C. B., "The Trade in West African Art," *African Arts,* 24(1):38–43, 1991.

Thompson, J. L. and S. Vogel, *Closeup: Lessons in the Art of Seeing African Sculpture*. New York: The Center for African Art, 1991.

Thompson, R., *Black Gods and Kings: Yoruba Art at UCLA*. Los Angeles: University of California, 1971.

Trowell, M., *African Design*. New York: Praeger Publishers, 1970.

Vansina, J., *Art History in Africa: An Introduction to Method*. London: Longman, 1984.

———, "Long-Distance Trade Routes in Central Africa," *Journal of African History*, 3(3):375–390, 1962.

Vogel, S., *Africa Explores Twentieth Century African Art*. New York: The Center for African Art, 1991.

———, "Beauty in the Eyes of the Baule: Aesthetics and Cultural Values," *Working Papers in the Traditional Arts*. No. 6, 1980.

———, "People of Wood: Baule Figure Sculpture," *Art Journal*, 23(1):23–26, 1973.

Wardwell, A., *African Sculpture: From the University Museum University of Pennsylvania*. Philadelphia: Philadelphia Museum of Art, 1986.

———, *Yoruba: Nine Centuries of African Art and Thought*. New York: The Center of African Art/Harry N. Abrams Inc.,Publishers, 1989.

Wassing, R. S., *African Art: Its Background and Traditions*. New York: Portland House, 1968.

Willis, L., "Uli Painting and the Igbo World View," *African Arts,* 23(1):62–67, 1989.

RESOURCES: PERIODICALS & VIDEO

PERIODICALS

Information about African art and culture can be found in many different art, anthropology, economics, ethnography and archaeology journals and magazines. Many of these journals and magazines are published abroad and may be in foreign languages.

African Arts
J. S. Coleman African Studies Center
University of California
Los Angeles, California 90024-1310
 A quarterly journal containing scholarly and popular articles, book reviews and exhibition reviews.

ACASA Newsletter
Arts Council of the African Studies Association
Los Angeles
 The Arts Council is a forum for exchange between African art historians. The Newsletter includes research notes, news and announcements.

African Archaeological Review
Cambridge University Press
 An annual review which documents the excavations and studies of African Antiquities.

Arts d'Afrique Noire
B.P. 24
95400, Arnouville, France
 This quarterly journal which counterbalances *African Arts* highlights Francophone Africa. It includes exhibition reviews, reports on African arts auctions, and articles on collectors and collections.

RES: Anthropology and Aesthetics
Peabody Museum of Archaeology and Ethnology
Harvard University
Cambridge, Massachusetts
 RES is a forum for exploring "aesthetic objects" and "cult objects" in all societies, archaic, historic and modern.

African Studies Review
Credit Union Building
Emory University
Atlanta, Georgia 30322
 African Studies Review is published three times a year. The journal features articles on all aspects of African culture as well as book reviews.

Natural History
American Museum of Natural History
New York

Tribal Arts Review
P.O. Box 15453
Seattle, Washington 98115
 A quarterly review focusing on book reviews, bibliographic essays, and critical articles on African, Native American and Oceanic art.

Africa
International African Institute
38 King Street
London, WC2E 8JR U.K.
 An ethnographic journal which publishes articles about African art.

Information on African art may also be found in fine arts journals such as: *Art Bulletin, Art Journal, ARTnews, Arts Review, Artforum, Ceramic Review, Ceramics Monthly, Connoisseur,* and *Journal of Aesthetics and Art Criticism.*

VIDEO

Africa Calls: Its Drums and Musical Instruments
 An African lives, works and communicates through his music. Junior High–adult. 1971. 23 minutes. Distributed by Carousel Film and Video, 160 Fifth Avenue, Room 405, New York, NY 10001. (212) 683-1660.

African Art and Sculpture
 Reveals the African's sense of beauty and curiosity as displayed in works of art. Junior High–adult. 1971. 21 minutes. Distributed by Carousel Film and Video, 160 Fifth Avenue, Room 405, New York, NY 10001. (212) 683-1660.

African Carving: A Dogon Kanaga Mask

The story of the Kanaga mask, used by the Dogon people of West Africa in deeply sacred rituals. Shows how the mask is carved and explains the function of the mask in Dogon society. Primary–adult. 1975. 19 minutes. Distributed by Phoenix/BFA Films, 468 Park Avenue South, New York, NY 10016. (212) 684-5910 and 1-800-221-1274.

African Craftsman: The Ashanti

This film illustrates that the Ashanti of West Africa are skilled in various arts, including cloth printing, weaving and woodcarving. Junior and Senior High. 1970. 11 minutes. Distributed by Phoenix/BFA Films, 468 Park Avenue South, New York, NY 10016. (212) 684-5910 and 1-800-221-1274.

Dance of the Spirit

The music, dance, costumes and masks of African ethnic groups are displayed. Senior High–adult. 1988. 30 minutes. Distributed through the University of Iowa.

Yaaba Soore: Path of the Ancestors

This film explains what the various African tribal masks represent. Senior High–adult. 1987. 17 minutes. Distributed by Carousel Film and Video, 160 Fifth Avenue, Room 405, New York, NY 10001. (212) 683-1660.

African Religions and Ritual Dances

Re-enactment of a Yoruba ritual cult dance. Junior High–adult. 1971. 19 minutes. Distributed by Carousel Film and Video, 160 Fifth Avenue, Room 405, New York, NY 10001. (212) 683-1660.

Ancient Africans

The film traces the roots of African history from the fabled kingdoms of Kush and Zimbabwe in the east and Ghana, Mali and Songhai in the west. Primary–adult. 1970. 27 minutes. Distributed by International Film Foundation, 155 West 72nd Street, New York, NY 10023. (212) 580-1111.

The Art of the Dogon

Footage from the Lester Wunderman Collection at the Metropolitan Museum of Art. It presents the art and ritual of the Dogon people in Mali, West Africa. Senior High–adult. 1988. 28 minutes. Distributed by artsAmerica, Inc., 12 Havermeyer Place, Greenwich, CT 06830. (203) 669-4693.

A Drum is Made: A Study in Yoruba Carving

Nigerian artisans carve and play the famous "talking drums" of Africa and explain the significance of the drum in the social and religious life of Nigeria. Senior High–adult. 1978. 24 minutes. Distributed by International Film Bureau Inc., 155 West 72nd Street, New York, NY 10023. (212) 580-1111.

African Art

The influence of contemporary African history on today's artist is outlined. Junior High–adult. 13 minutes. Distributed by Journal Film, Inc., 560 Sherman Avenue, Suite 100, Evanston, IL 60201. (708) 328-6700.

The Art of West African Strip-Woven Cloth

The tape can be taken out on loan from the Education Department of the National Museum of African Art, Smithsonian Institution. 1987.

Nigerian Art: Kindred Spirits

A look at the historical evolution of contemporary Nigerian art, while recognizing the role and function of traditional Nigerian art in the creation of contemporary art. Junior High–adult. 1990. 58 minutes. Distributed by Smithsonian World Series, Washington, DC. Comes with accompanying teacher's guide. 1-800-522-1922.

Of Leaves and of Earth

The film takes a look at traditional architecture of the Cameroon. Primary–adult. 45 minutes. Distributed by The Roland Collection, 1344 South 60th Court, Cicero, IL 60650. 1-800-597-6526.

The World Began at Ile-Ife: Meaning and Function in Yoruba Art

Produced in conjunction with the exhibition entitled *Yoruba: Nine Centuries of African Art and Thought,* this video supplies a context for the objects and retells the creation myth of the Yoruba. 1990. 18 minutes. Distributed by The Art Institute of Chicago, 111 South Michigan Avenue, Chicago, IL 60603-6110. 312-443-3600.

Back to Africa

A Jamaican documents his experience as a person of African descent traveling through Africa. 58 minutes. Distributed by WNET, Box 2284, South Burlington, VT 05407-2284. 1-800-336-1917.

Potters of Buur Heybe, Somalia

A documentary video of Somali pottery production with rare footage that focuses on the role of the potter within the village, oral traditions about the origin of pottery and stages of pottery development. Junior High–adult. 25 minutes. Distributed by Filmmakers Library, 124 East 40th Street, New York, NY 10016.

Beauty and the Beast

This film of field footage about Ibo spirit dancers compares and contrasts two masking cults from one community. High school–adult. 1983. 34 minutes. Distributed by Karen Morrell, African Encounters, University of Washington, Seattle, WA 98195. (206) 543-9288.

Introduction to the Art and History of the Akan

This video was produced in conjunction with an exhibition of Akan art from Ghana at the University of Washington Museum of Art. It provides a general introduction to the history and the art of the Akan people. Fourth grade–adult. 1985. 15 minutes. Distributed by Karen Morrell, African Encounters, University of Washington, Seattle, WA 98195. (206) 543-9288.

Many of these videos are for sale or lease. Teachers should contact the distributors for catalogues and prices, and are advised to preview videos for appropriateness to grade level and subject matter.

WHERE TO SEE AFRICAN ART

Examples of African art can be found in most major museums throughout the United States. In addition, many galleries and universities have African art holdings.

Following is a list of museums and galleries in the United States that have permanent displays or frequently exhibit African art. Readers should note that this is not a comprehensive list. ** Indicates major collections.

ARIZONA
Arizona State University Art Collections, Tempe
Heard Museum of Primitive Art, Phoenix
Sedona Arts Center, Sedona

CALIFORNIA
Bowers Museum, Santa Ana
Fine Arts Museums of San Francisco, San Francisco
Fowler Museum of Cultural History, UCLA, Los Angeles **
Hearst (formerly Robert H. Lowie) Museum of Anthropology, University of California, Berkeley **
La Jolla Art Center, La Jolla
Los Angeles County Museum, Los Angeles
San Diego Museum of Art, San Diego
Stanford University Museum of Art, Stanford

COLORADO
Denver Art Museum, Denver

CONNECTICUT
Yale University Art Gallery, New Haven

DISTRICT OF COLUMBIA
Department of Anthropology, National Museum of Natural History, Smithsonian Institution, Washington, DC
Howard University Museum of Art, Washington, DC
National Museum of African Art, Smithsonian Institution **

FLORIDA
Lowe Art Museum, University of Miami, Miami
University of Florida Art Gallery, Gainesville

GEORGIA
High Museum of Art, Atlanta **
Spelman College, Atlanta

HAWAII
Honolulu Academy of Arts, Honolulu

ILLINOIS
Art Institute of Chicago, Chicago **
Ewing Museum of Nations, Illinois State University, Normal
Field Museum of Natural History, Chicago **
First National Bank of Chicago, Chicago
May Weber Foundation, Chicago

INDIANA
Herron Museum of Art, Indianapolis
Indiana University Art Museum, Bloomington **
Indianapolis Museum of Art, Indianapolis
Snite Museum of Art, University of Notre Dame, South Bend

IOWA
University of Iowa Museum of Art, Iowa City **

KANSAS
Kauffman Museum, North Newton
Martin and Osa Johnson Safari Museum, Chanute

KENTUCKY
University of Kentucky Art Museum, Lexington

LOUISIANA
Amistad Research Center, Tulane University, New Orleans
New Orleans Museum of Art, New Orleans
Southern University of New Orleans, New Orleans

MARYLAND
Baltimore Museum of Art, Baltimore **
Morgan State University Gallery of Art, Baltimore
University of Maryland Art Gallery, College Park

MASSACHUSETTS
Peabody Museum of Archaeology and Ethnology, Cambridge **
Peabody Museum of Salem, Salem
Museum of Fine Arts, Boston
University of Massachusetts Art Gallery, Amherst

MICHIGAN
Detroit Institute of Art, Detroit **
Kalamazoo Institute of Art, Kalamazoo
Kresge Art Museum, Michigan State University, East Lansing
University of Michigan Museum of Art, Ann Arbor

MINNESOTA
Minneapolis Institute of Arts, Minneapolis
Minnesota Museum of Art, St. Paul
St. Paul Art Center, St. Paul

MISSOURI
Nelson-Atkins Museum of Art, Kansas City **
St. Louis Art Museum, St. Louis
University of Missouri-Columbia Museum of Art & Archaeology, Columbia

NEW HAMPSHIRE
Hood Museum of Art, Dartmouth College, Hanover **

NEW JERSEY
Montclair State College, Montclair
Newark Museum, Newark
Princeton University Art Museum, Princeton
Society of African Missions, Tenafly

NEW MEXICO
Museum of International Folk Art, Santa Fe

NEW YORK
American Museum of Natural History, New York City **
Brooklyn Children's Museum, Brooklyn
Brooklyn Museum, Brooklyn **
Buffalo Society of Natural History, Buffalo **
Metropolitan Museum of Art, Michael C. Rockefeller Wing, New York City **
Queens Museum, Queens
Schomberg Center for Research in Black Culture, New York City
Staten Island Museum, Staten Island
Syracuse University School of Art, Syracuse
University of Rochester Memorial Art Gallery, Rochester

NORTH CAROLINA
Mint Museum, Charlotte
William Hayes Ackland Memorial Art Center, University of North Carolina at Chapel Hill, Chapel Hill

OHIO
Central State University, Wilberforce
Cincinnati Art Museum, Cincinnati
Cleveland Art Museum, Cleveland **
Cleveland Museum of Natural History, Cleveland
Cleveland State University, Afro-American Cultural Center, Cleveland
Dayton Art Institute, Dayton
Toledo Museum of Art, Toledo

OKLAHOMA
Kirkpatrick Center, Oklahoma City

OREGON
Portland Art Museum, Portland

PENNSYLVANIA
Barnes Foundation, Merion
Carnegie Institute, Department of Fine Arts, Pittsburgh
Dickinson College, Carlisle
Lincoln University, Lincoln
University of Pennsylvania, University Museum, Philadelphia **

RHODE ISLAND
Haffenreffer Museum, Brown University, Bristol

SOUTH CAROLINA
L. P. Stanback Museum & Planetarium, South Carolina State College, Orangeburg

TENNESSEE
Fisk University Art Gallery, Nashville
Memphis State University Art Gallery, Memphis

TEXAS
Dallas Museum of Fine Arts, Dallas **
Kimball Art Museum, Fort Worth
Menil Collection, Houston
Museum of Fine Arts, Houston

VIRGINIA
George Mason University, Fairfax
Hampton University, Hampton **
Virginia Museum of Fine Arts, Richmond **

WASHINGTON
Seattle Art Museum, Seattle **

WISCONSIN
Milwaukee Public Museum, Milwaukee

INDEX